SIDMOUTH TO BEER

THROUGH TIME

Steve Wallis

AMBERLEY PUBLISHING

First published 2011

Amberley Publishing
The Hill, Stroud
Gloucestershire, GL5 4EP

www.amberley-books.com

Copyright © Steve Wallis, 2011

The right of Steve Wallis to be identified as the
Author of this work has been asserted in accordance
with the Copyrights, Designs and Patents Act 1988.

ISBN 978 1 84868 900 8

British Library Cataloguing in Publication Data.
A catalogue record for this book is available from
the British Library.

Typeset in 9.5pt on 12pt Celeste.
Typesetting by Amberley Publishing.
Printed in the UK.

Introduction

This book looks at the town of Sidmouth and three smaller settlements that lie along the coast to the east – Salcombe Regis, Branscombe and Beer. Although quite close to one another, they are very different places. Sidmouth is a classic seaside resort flanked by distinctive red sandstone cliffs, Salcombe Regis occupies a narrow valley that leads down to the sea, Branscombe is a series of separate settlements scattered through a much larger valley, and Beer sits at the head of a cove among white chalky cliffs and retains much of the character of a fishing village.

This stretch of the East Devon coast includes part of England's only Natural World Heritage Site. Known in full as the Dorset and East Devon Coast World Heritage Site, it is often shortened to the 'Jurassic Coast'. The designation covers the cliffs between Exmouth some ten miles to the west of Sidmouth, eastwards along the majority of the Dorset coast to the Swanage area. The status was gained because of the geological importance of the cliffs and the fossils therein, but in many people's eyes it is also linked to the natural beauty of this coastline.

That beauty has long been recognised, and together with what were seen as the healthy properties of the sea and its air, this has brought people on holiday to the area, especially to Sidmouth, for over two hundred years. In the last years of the nineteenth century, they started sending each other postcards, which are the source of most of the old photographs used in this book. Today we think of postcards primarily as a way of sending holiday greetings, and that was one of their main uses then as well. But they were also used for more day-to-day communications too, such as invitations to tea and the like. In fact, many people probably sent them almost as often as we send e-mails and text messages today.

I have tried to match the viewpoints of my 'modern' photographs as closely as I can to those used by the old photographers. In some cases, this has been impractical because the view from that spot is now obscured by trees and vegetation, new housing or the like. Also, some of the old pictures were taken from private land, whereas I have kept to public rights of way. When unable to us the 'original' spot, I have usually taken my photograph from as close as possible to it, but have sometimes broken this rule to get a better view of the subject.

The dates given are estimates of when the older pictures were taken.

An Introduction to Sidmouth

Sidmouth from Salcombe Hill.

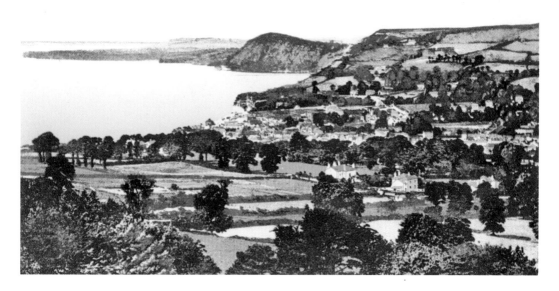

Sidmouth from Salcombe Hill, c. 1905

I will start with a pair of views of Sidmouth that look from Salcombe Hill on the east side of the town. From here, it is easy to appreciate the spectacular location that, between the late 1700s and mid-1800s, turned the little fishing village at the mouth of the River Sid into a major tourist resort.

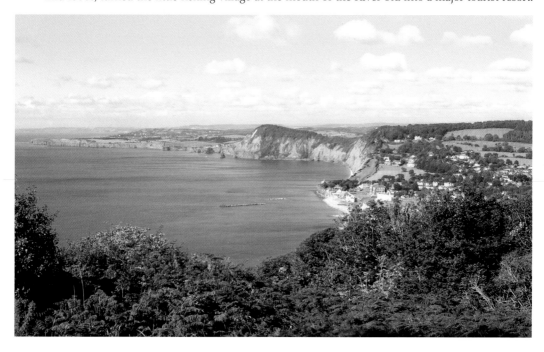

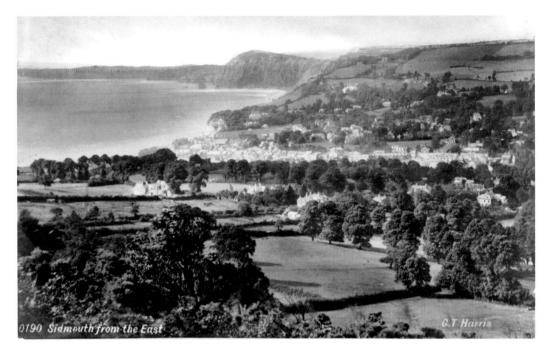

0190 Sidmouth from the East

G.T Harris

Sidmouth from Salcombe Hill, c. 1905

These views also illustrate how Sidmouth has had to develop. It has only a short seafront with rising ground on either side. That seafront filled quickly with lodging houses and hotels, and the town had to grow inland along a fairly narrow corridor. The viewpoint of the older photograph is now obscured by trees, and my photograph here is taken from lower down the hill.

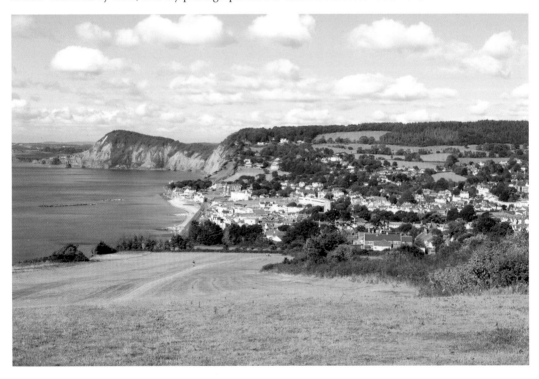

Along the Esplanade

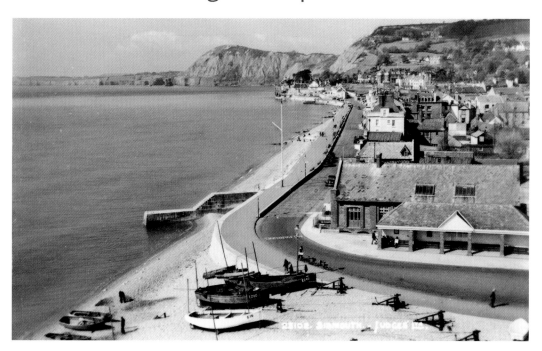

The Esplanade, c. 1930

Next we go down towards the town for some views of the Esplanade. We will start at the eastern end and head along before turning around and coming back. The old view here was taken from a location partway down the hill that is no longer accessible, so mine shows the shelter building in the foreground of that picture.

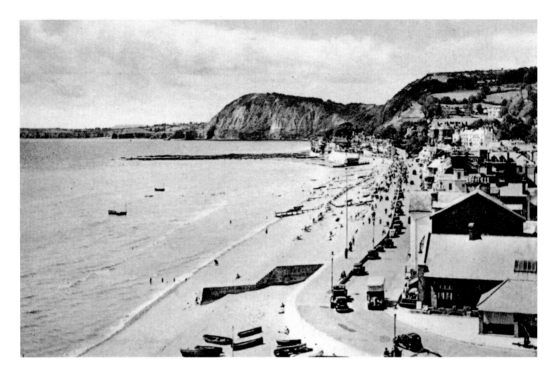

The Esplanade, c. 1935

This is a similar view to the previous old photograph, but showing much more activity. It looks as though this one was taken during the tourist season since everything seems focused on the beach. My photograph shows the eastern end of the Esplanade just around the corner from the shelter.

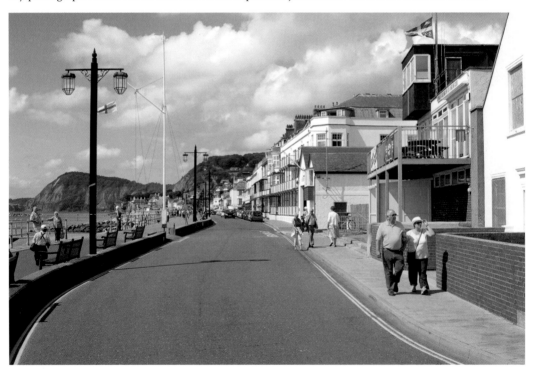

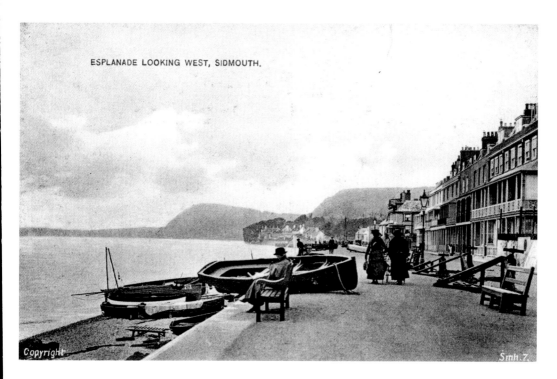

ESPLANADE LOOKING WEST, SIDMOUTH.

York Terrace, *c.* 1920

The viewpoints of the old and new photographs now become more synchronised as we start to move westwards along the Esplanade. Sidmouth was a working fishing port just as much as a tourist destination a century ago, as the fishing boat 'parked' on the Esplanade illustrates! The houses with balconies on the right are York Terrace, some built around 1810, while the red-brick ones on the right were added between 1909 and 1911.

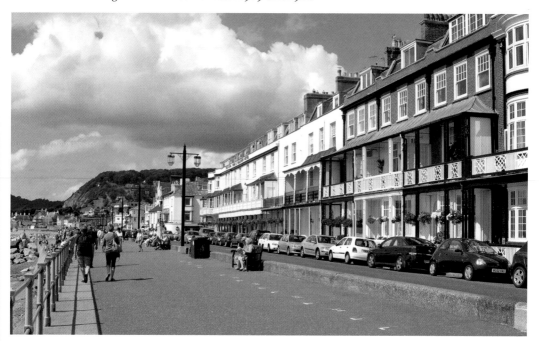

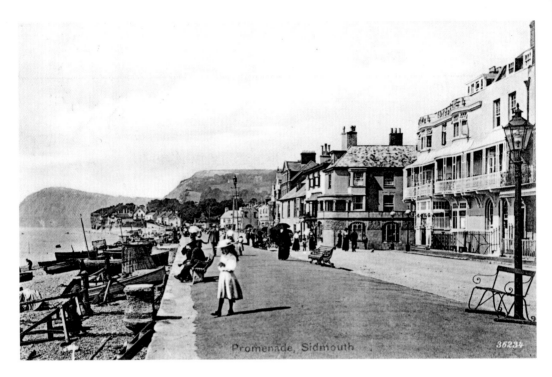

Promenade, Sidmouth

36234

Royal York Hotel, *c.* 1900

Heading on a short distance we see on the right what was originally the Royal York Hotel. Today it has combined with the Faulkner Hotel next door. They were part of the same build as York Terrace, and the Royal York was the town's first purpose-built hotel.

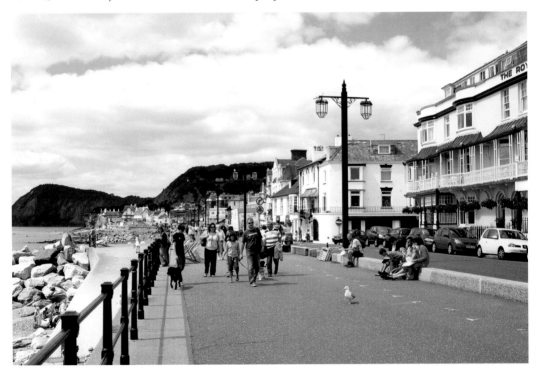

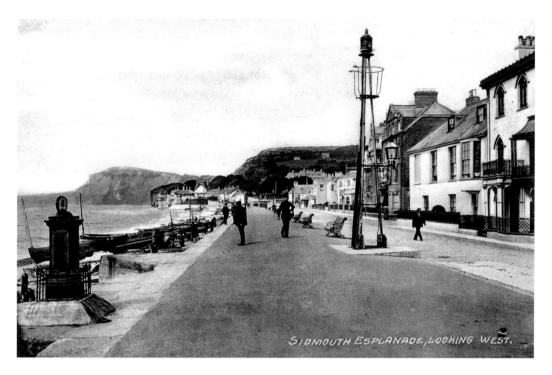

Beach House, c. 1910

Again we move only a few yards before finding two buildings on the right that are of interest. The three-storey one with the attractive balconies is Beach House, dating from the eighteenth century and probably the oldest of the seaside villas in the town. The Mocha Restaurant next door was known as 'The Shed' two hundred years ago when it was just a shelter for visitors with a billiard room above.

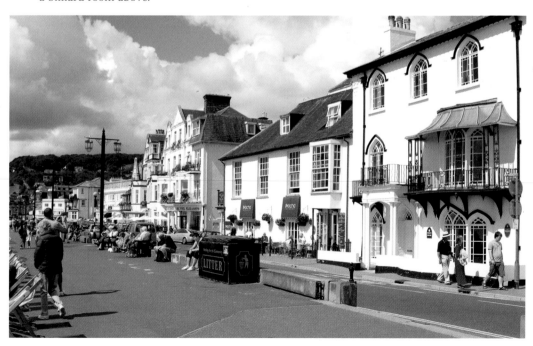

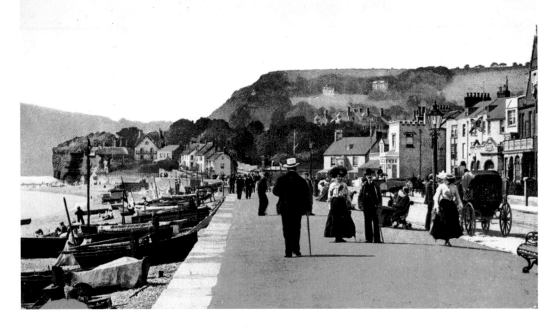

Changing Buildings, *c.* 1905

Once more we advance a short distance, but this time the buildings on our right are not as easy to recognise from one photograph to the other. I will leave some of them until our return back along the Esplanade, but here we get our only view of the Riviera Hotel. This is the prominent white building in my photograph, built around 1820 and which underwent alterations in the twentieth century, including the addition of an extra storey.

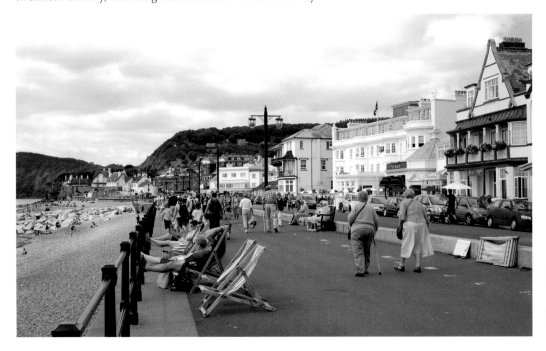

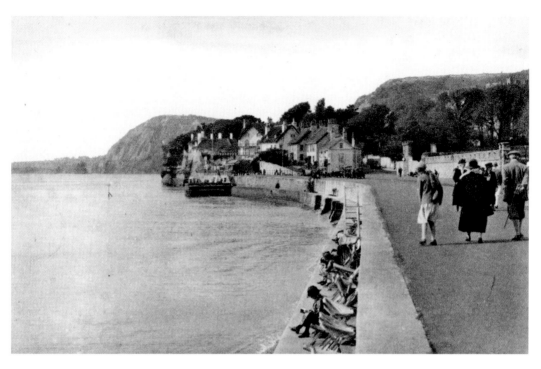

A More Open View, *c.* 1930

Now nearing the western end of the Esplanade, the buildings are larger and set further back from the seafront. On the right we see the crenellated wall of the grounds of the Belmont Hotel and, in my photograph at least, the Victoria Hotel.

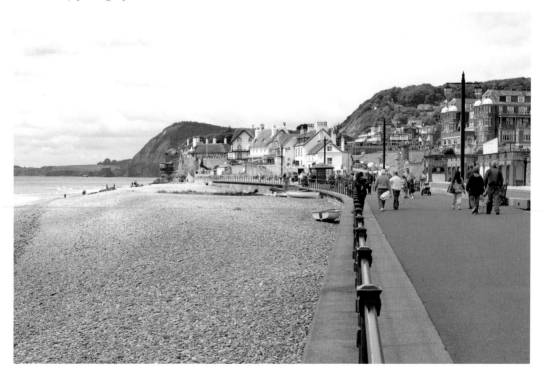

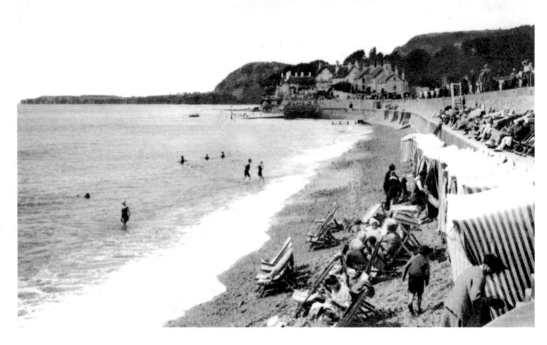

View From Breakwater, c. 1925

Stepping out onto the breakwater we get a good view of Sidmouth's shingly beach. As you probably noticed in the last pair of photographs, where there is now just a railing on the edge of the Esplanade, there was once a broad step that made a good location for sunning one's self.

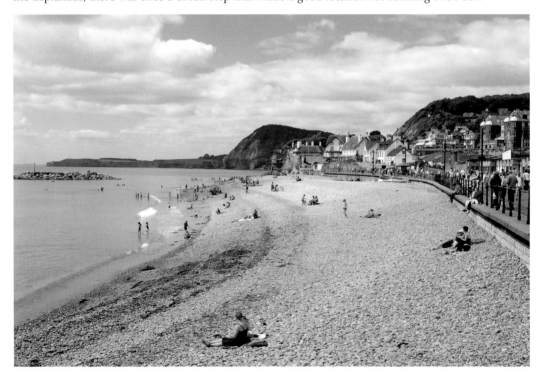

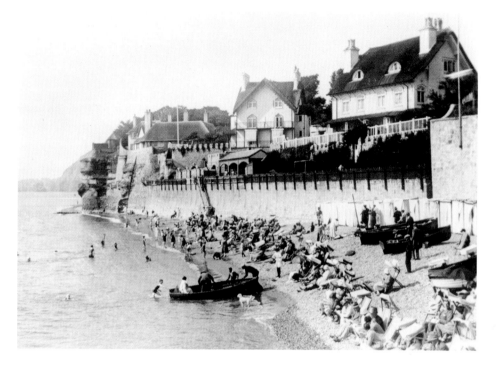

Clifton, *c.* 1925

We go further out onto the beach next for a look at the houses in the small area known as Clifton. Rook Cottage on the right was the first building here, dating from 1794, and rebuilt after a fire in 1908. The styles of all three properties seen here complement one another very nicely. The people on the top of the rocks to the left of the houses in my picture are at the lookout point at the end of Connaught Gardens.

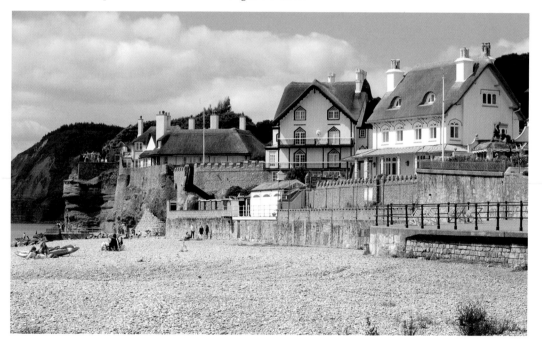

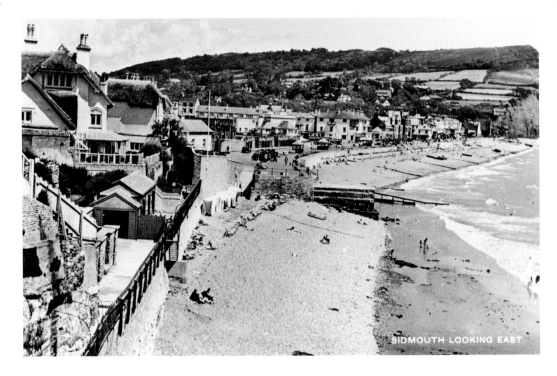

Esplanade from Connaught Gardens, *c*. 1935

We have now reached the end and must turn around. These photographs show the view back along the Esplanade from the Connaught Gardens lookout point. The houses seen in the previous view are now on the left.

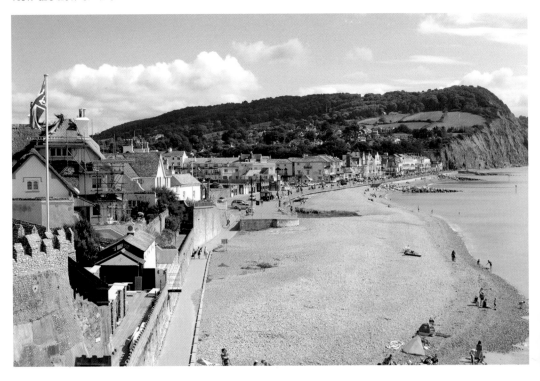

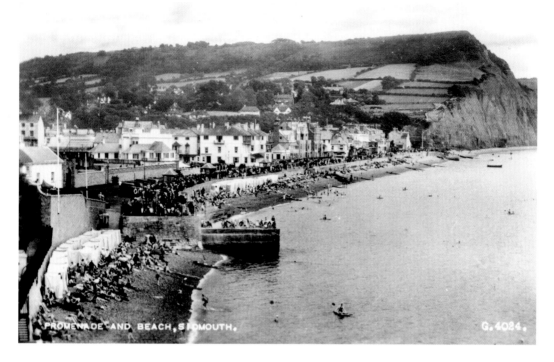

Esplanade from Connaught Gardens, *c.* 1935
The photographer of this old view used the same viewpoint as the last one, but shifted their view around to get a wider view of the whole Esplanade on a busier day. In the lower left are the little tent-like shelters we saw from the breakwater three pictures back.

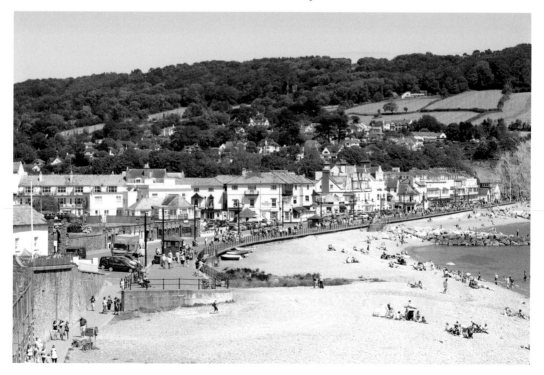

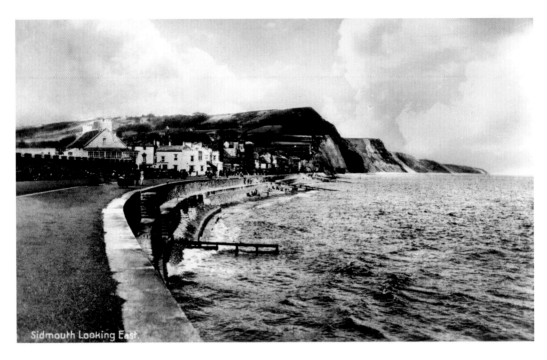

Sidmouth Looking East.

Back Down to the Esplanade, *c.* 1930

Now we start back along the Esplanade, beginning at a viewpoint just past the houses of Clifton. Here we get a good view of the ledge seen before, which seems to extend for the whole length of the Esplanade. It is not visible in the earliest photographs used here, so I guess it was constructed in the early 1920s or thereabouts.

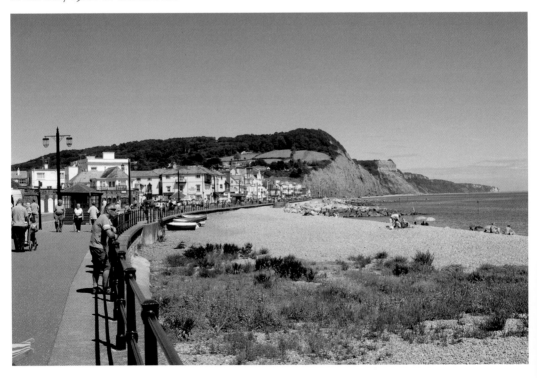

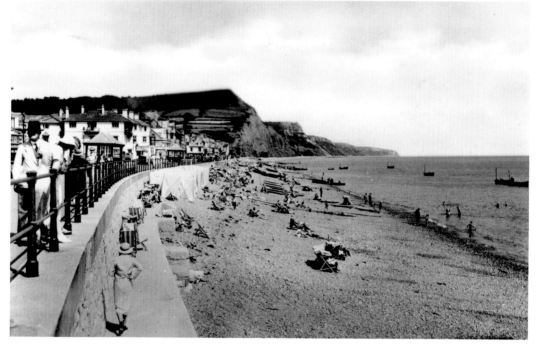

Railing, c. 1940

We move onward and look at a slightly later old photograph. The Esplanade now has a railing similar to what we see today. In fact, there is a reference to a railing here in 1810, so this was nothing new. The Bedford Hotel is coming into view on the left.

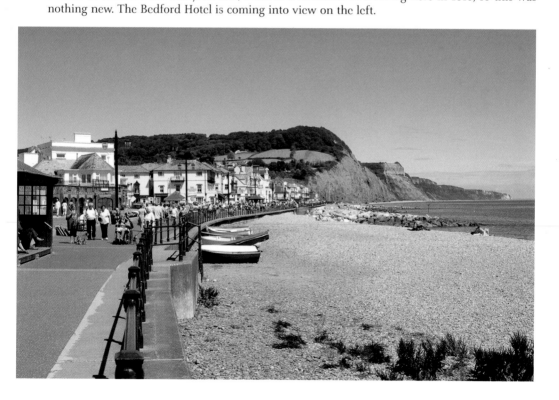

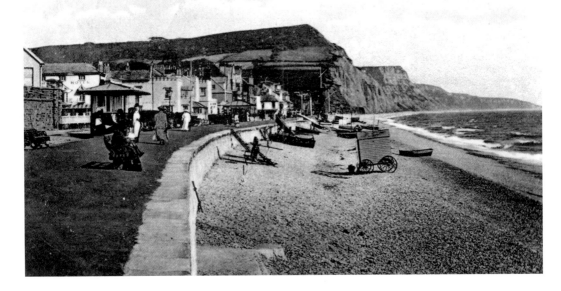

9038. Esplanade looking East. Sidmouth.

Beach Paraphernalia, *c.* 1910

Continuing on quite a short distance, but going back perhaps thirty years, we see an interesting collection of objects on the beach. The contraption with the wheels is a bathing machine, in which people could change whilst the machine was drawn by horses down to the sea, and there seem to be hoists against the wall of the Esplanade for lifting boats up off the beach.

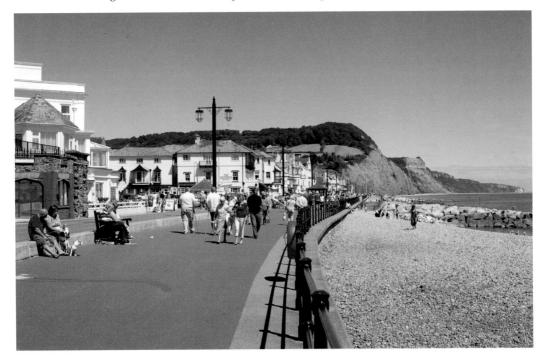

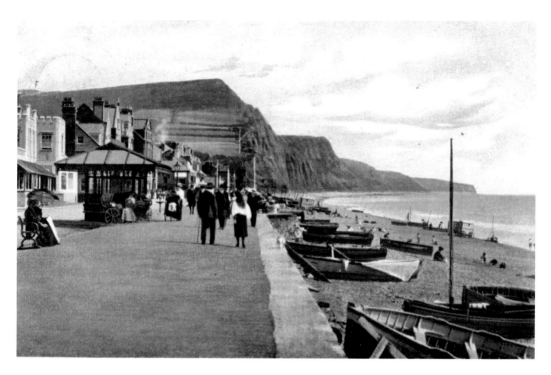

Bedford Hotel, *c.* 1900

Coming up towards the corner of Station Road, we see the Bedford Hotel on the left. Much of the side facing Station Road (seen in the last two views but not this one) is part of the original building, which dates from around 1810. It was extended a few years later.

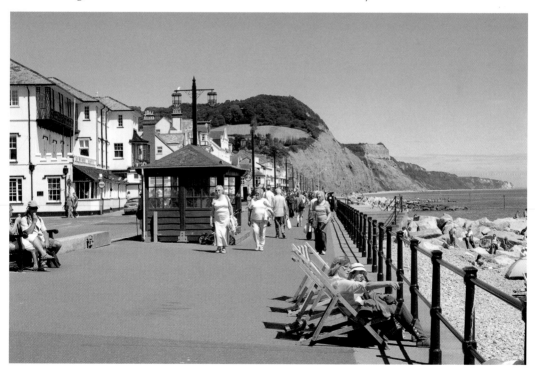

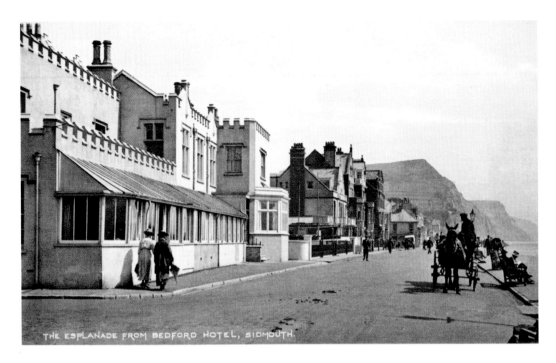

THE ESPLANADE FROM BEDFORD HOTEL, SIDMOUTH.

Bedford Hotel, *c.* 1910
Now we can get a good view of the Esplanade frontage of the Bedford Hotel. A quick look at the two photographs might make you might think that they are two different buildings, but look more closely and you see that much is the same, such as the long single-storey section nearest to us. It is the addition of an extra storey and balconies that has made the greatest difference to the building's appearance.

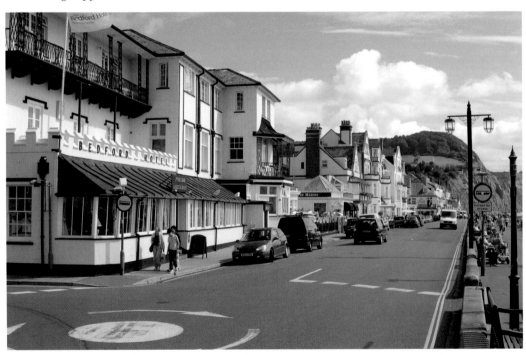

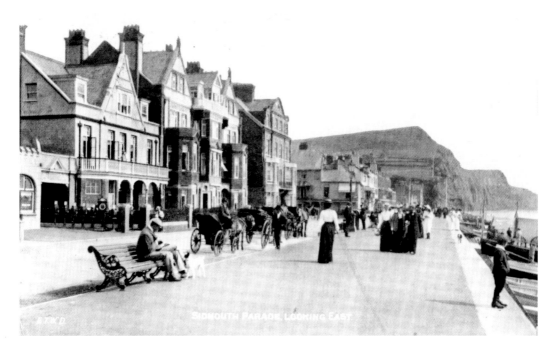

Hotels, *c.* 1910

Finally, on our tour up and down the Esplanade, we skip past the Riviera Hotel that we saw previously to a less-changed scene. The building on the very left (now the Marine pub) looks different, although we do not have a clear view, but the three big hotels here – the Kingswood, Devoran and Elizabeth – have not been altered to anywhere near the same extent as the Bedford or Riviera.

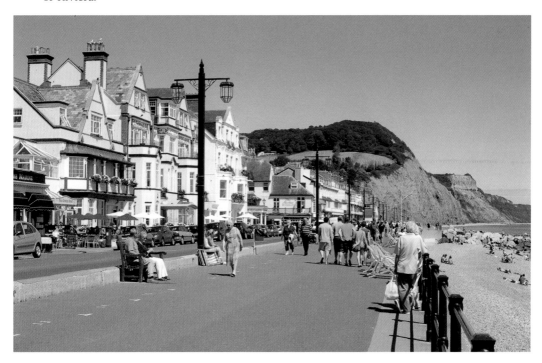

Around the Town

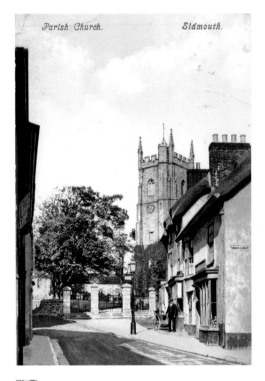

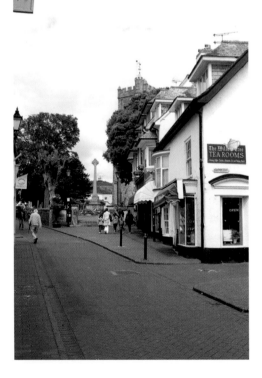

Church Street, c. 1905
Next we look at a variety of locations around Sidmouth, mostly inland or at least set back from the sea. As a sample of the lovely little streets of the old town, we begin with three views of Church Street, seen here from close to where Eldon Court branches off.

Church Street, _c._ 1925
Here is a slightly later old photograph
taken from a short distance further up the
street, which allows for a better view of the
frontages of the buildings on the right of the
previous view. The dormers and bay windows
that we see today on some of these buildings
complement them rather well.

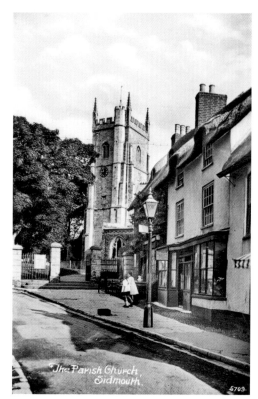

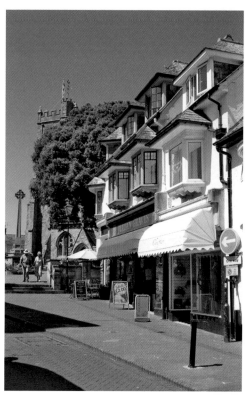

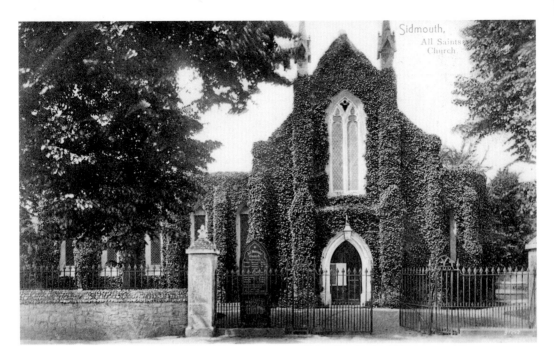

Parish Church, *c.* 1910

Now up to the top for a look at the parish church. It is dedicated to Saints Giles and Nicholas, the latter being particularly appropriate as the patron saint of fishermen. The tower dates from the fifteenth century, and the rest was rebuilt in 1860. Inside there is a memorial window presented in 1867 by Queen Victoria in memory of her father, the Duke of Kent.

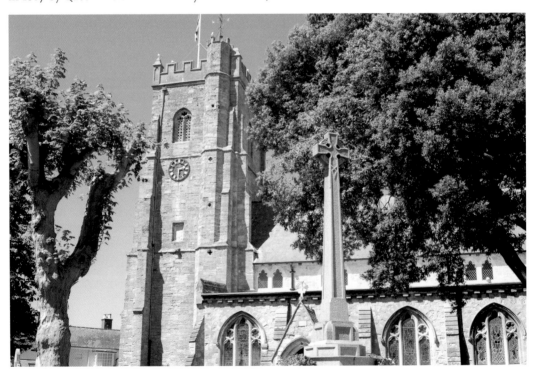

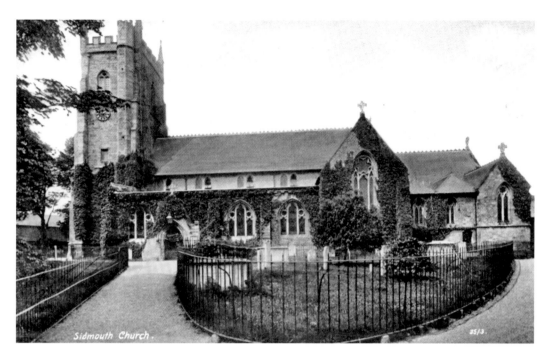

Sidmouth, All Saints Church, c. 1900
This is another of the town's churches, built in 1837 in the road that bears its name to serve some of the expanding suburbs of the town. The two photographs give the lie to the idea that churches tend not to change much. For instance, the upper window on the front gable has been shortened and a clock added, the two pinnacles on top of the gable have gone, and the picturesque but damaging ivy has been removed.

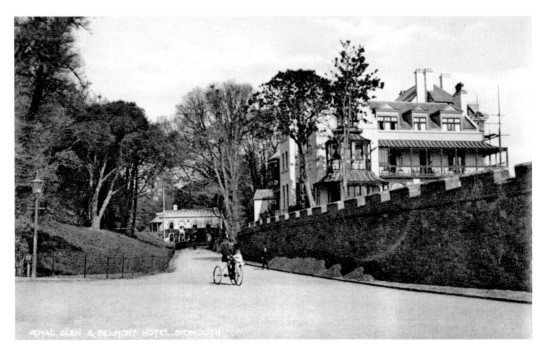

Sidmouth, the Royal Glen Hotel and Belmont Hotel, *c.* 1910
Just behind the western end of the seafront there is a group of grand hotels set back in their own grounds. This view looks from High Peak Road down Glen Road, with the Royal Glen Hotel in the distance and the Belmont Hotel on the right. As the two photographs show, the latter has been enlarged considerably. This happened around 1920.

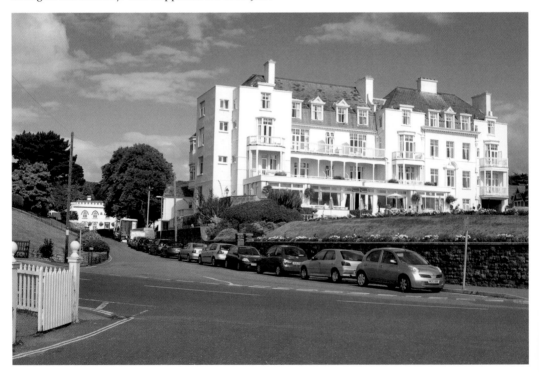

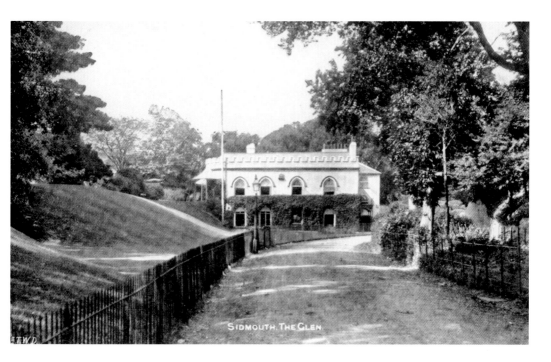

Sidmouth, the Royal Glen Hotel, *c.* 1910

Next a closer view of the Royal Glen Hotel, which was built around 1700, making it one of the oldest surviving buildings in the town. It has changed its name several times, and in 1819, when known as Woolbrook Cottage, it was leased by the Duke of Kent, who lived there with his wife and infant daughter, the future Queen Victoria. In January of the following year, the Duke caught pneumonia and died here.

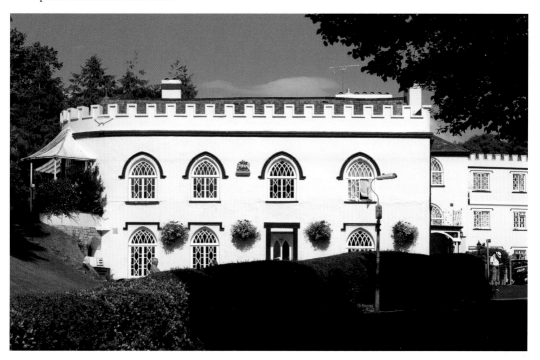

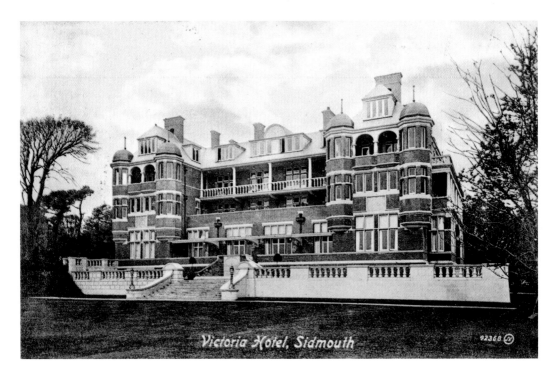

Sidmouth, Victoria Hotel, *c.* 1910

Close by, on the other side of Glen Road from the Belmont and facing High Peak Road, we find the largest hotel in the town. It dates from the late nineteenth century, and it is doubly fitting that it bears the name 'Victoria', since not only had she 'lived round the corner' as a child, but she was the reigning monarch when it was built.

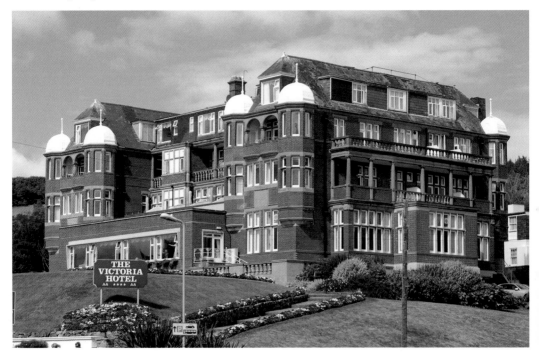

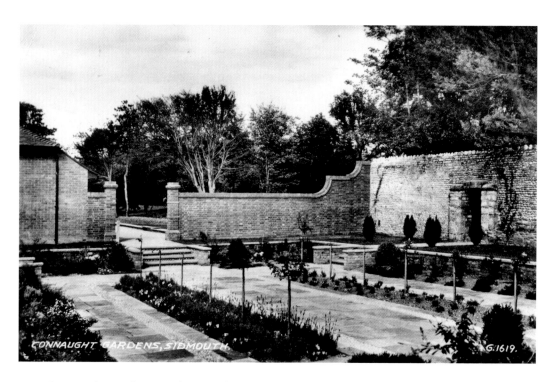

Connaught Gardens, Sunken Garden, c. 1935

Connaught Gardens are at the western end of the seafront where the land begins to rise towards Peak Hill. They were laid out between 1932 and 1934, formally opening in the latter year. This view of the part called the Sunken Garden, was probably taken just after the opening, and the planting here certainly looks recent.

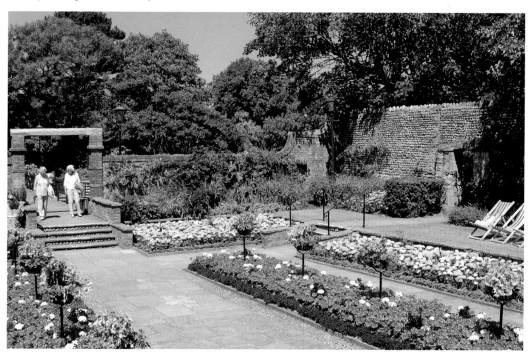

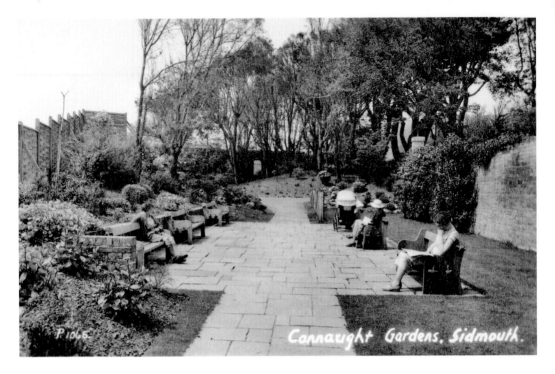

Connaught Gardens, *c.* 1935
Here is another view of around the same date, and again the planting looks new. I am relatively confident that the picture shows the area where the Display House, with its collection of cacti and succulents, is now.

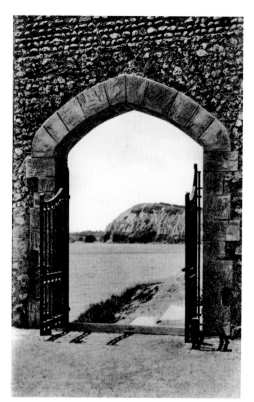

Connaught Gardens, Gateway, c. 1935
Lime Kiln Garden is over on the west side of
the Gardens, and gets its name from the nearby
site of an eighteenth-century lime kiln. This
ornamental gateway gives views out along the
cliffs, including High Peak, seen here.

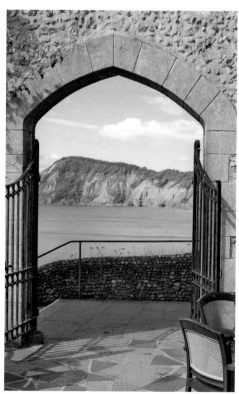

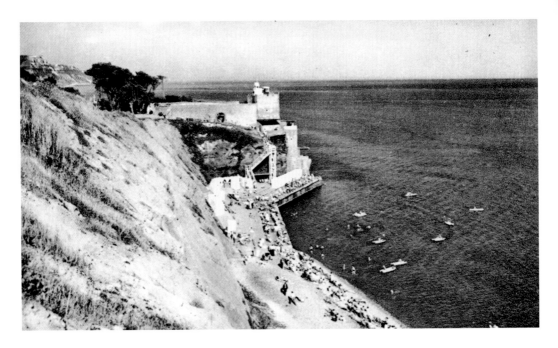

Jacob's Ladder, c. 1930

On the corner of Connaught Gardens overlooking the sea is the tower and staircase known as Jacob's Ladder. It was constructed in the eighteenth century as the lime kiln that gave its name to the adjacent garden, then was incorporated into the grounds of a house and, after various additions, it is now one of the landmarks of Sidmouth. Its name must come from the Bible story of the ladder to Heaven that appeared to Jacob in a dream.

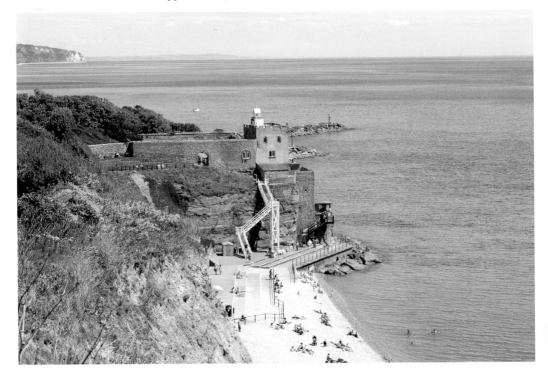

Up and Over Peak Hill

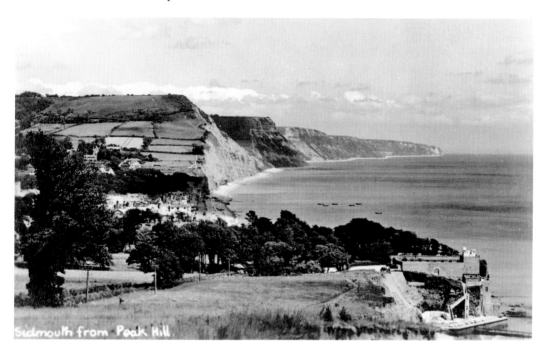

Sidmouth from Peak Hill

Wider View of Jacob's Ladder, *c.* 1930
Now for a series of views that takes us westwards out of the town and over Peak Hill to Ladram Bay. This older view looks back from the parkland that extends up the hill between Peak Hill Road and the cliffs. By contrast, mine was taken from a viewpoint on the side of High Peak.

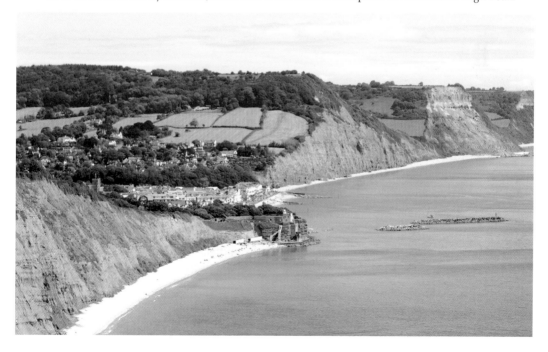

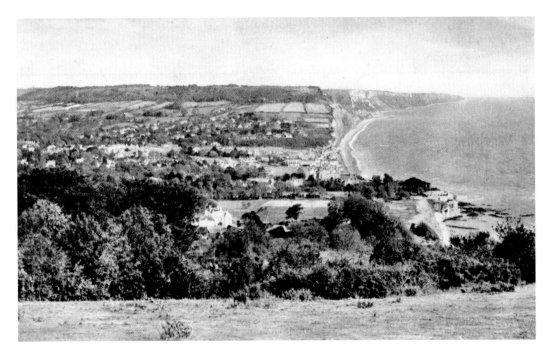

Sidmouth From Peak Hill, *c.* **1925**
Going further up Peak Hill, we get views of the town that are a reverse of the first two pairs in this book. The prominent building at the bottom of the hill in the old photograph is Peak House, built in 1904 for the President of the Prudential Assurance Company and used as a hospital for wounded servicemen during the First World War.

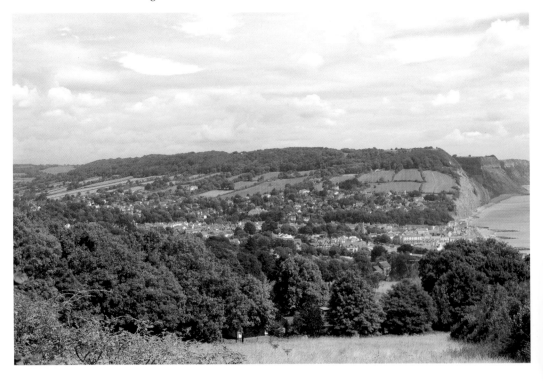

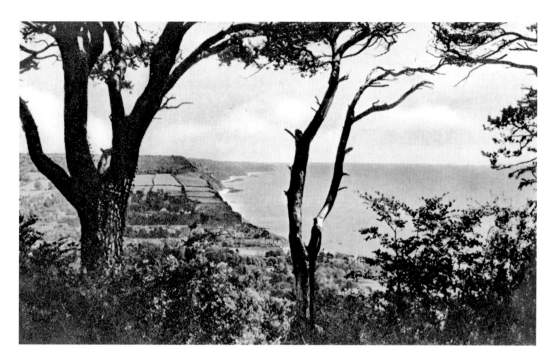

Sidmouth from Peak Hill, *c.* 1925

Both views here are from among the trees near the top of Peak Hill – mine looks through a gap in those that line Peak Hill Road. In both, we can see along the coast to the east, and in my photograph you will see how the red sandstone gives way to white chalk. The furthest clearly visible feature is Beer Head.

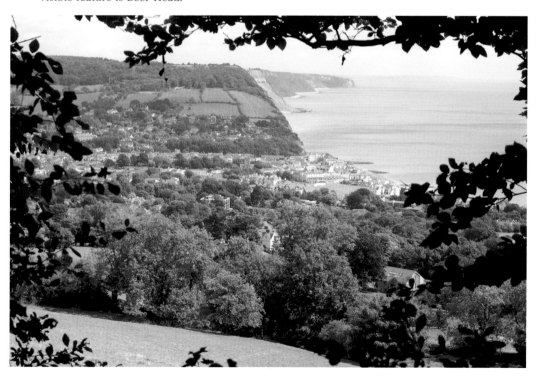

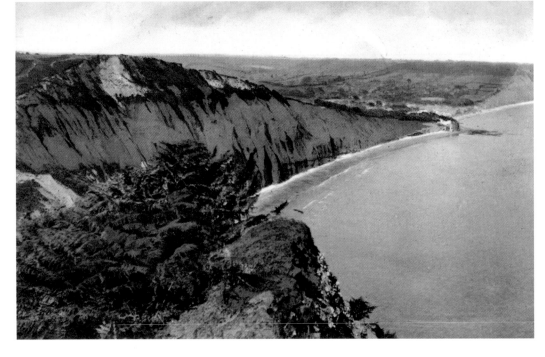

Peak Hill Cliffs, *c.* 1925
Now we follow the South-West Coast Path down through the valley of the Otterton Brook and up High Peak beyond. The old photograph looks from the top of High Peak (a height of nearly 500 feet) back to the cliffs below Peak Hill. Mine was taken from the viewpoint on the way up.

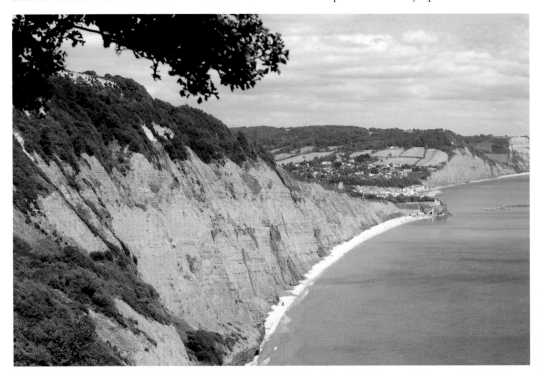

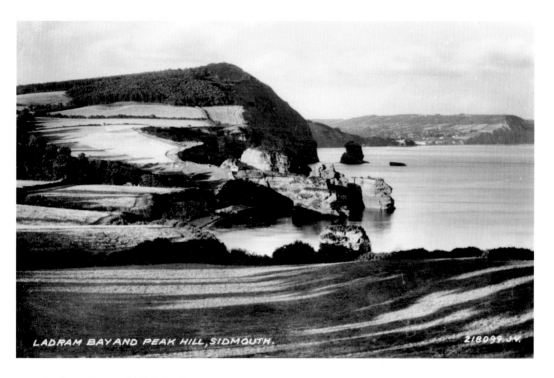

LADRAM BAY AND PEAK HILL, SIDMOUTH. 218099.J.V.

Ladram Bay and High Peak, *c.* 1935
Further along the path we reach Ladram Bay. From the far side we look back to see this view of the bay and High Peak beyond. The major change between the taking of the two photographs is the appearance of Ladram Bay Holiday Park.

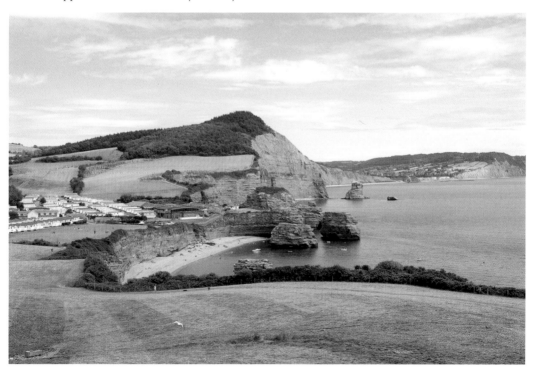

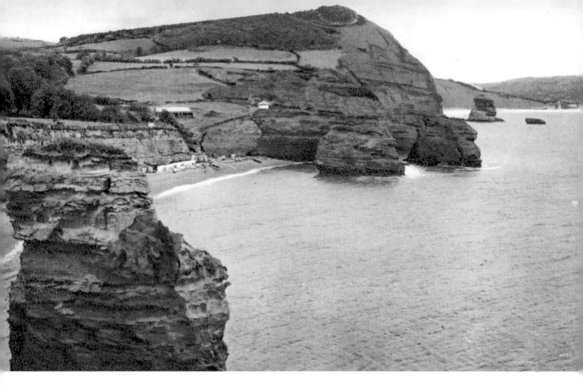

Rock in Ladram Bay, *c.* 1925
The sandstone cliffs here, as at Sidmouth, are made of Otter Sandstone that formed under desert conditions 220 million years ago in the Triassic Period. The cliffs are eroding, leaving rocks or stacks such as this one, which I believe is called 'King George III Rock'.

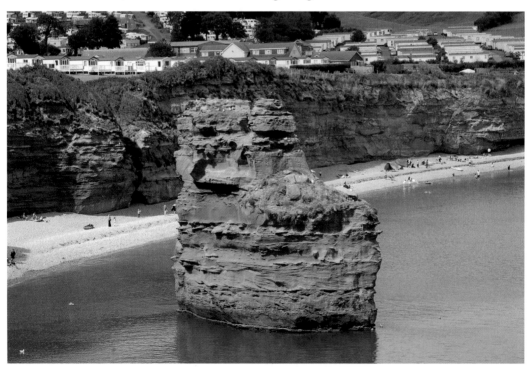

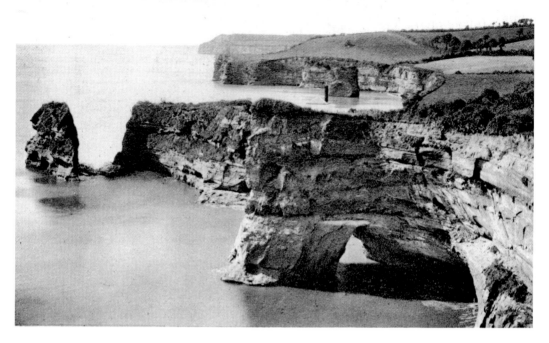

Ladram Bay, Opposite View, *c.* 1930
Back around on the north side of the bay now, we see Ladram Arch in the bottom right of the old photograph. My picture shows the spot where that photograph was taken from on the right, and Hern Point Rock on the left.

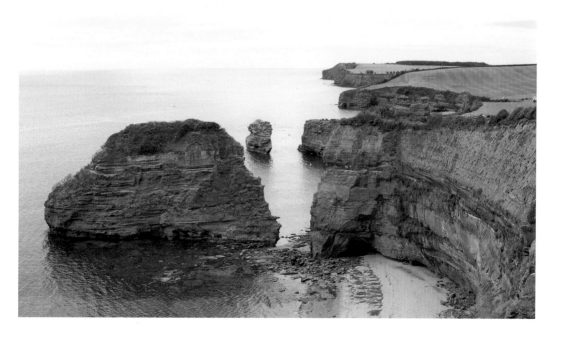

Up the Sid

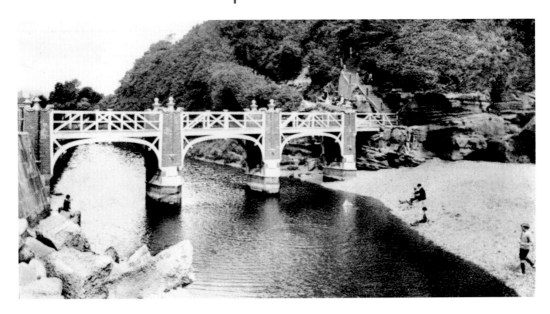

Alma Bridge, c. 1935

In this chapter we take a short journey up the River Sid, starting at its mouth at the eastern end of the Esplanade. A bridge was first constructed here in 1855 and named after the Battle of Alma that had taken place the previous year in the Crimea. The present bridge is a replacement, which, together with the path up the cliff on the right, was completed in 1903.

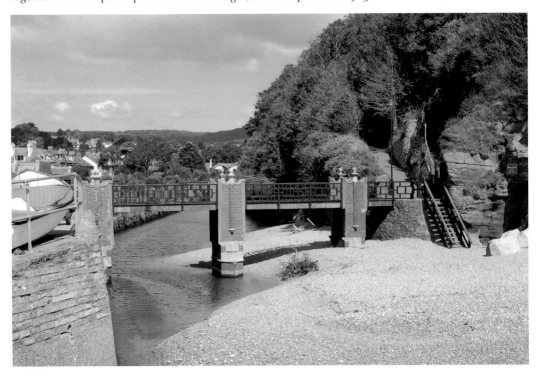

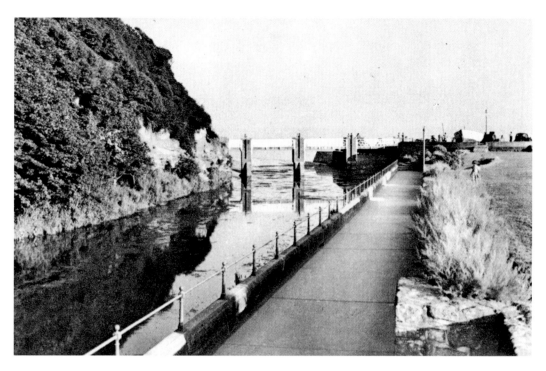

Alma Bridge and Ham Field, *c.* 1930

Now a view back to the bridge from a short distance upstream. To the right in the old photograph is what is now called Ham Recreational Field, which was presented to the town in 1896. Its previous name, 'The Marsh', suggests that a lot of work was needed before any recreation was possible.

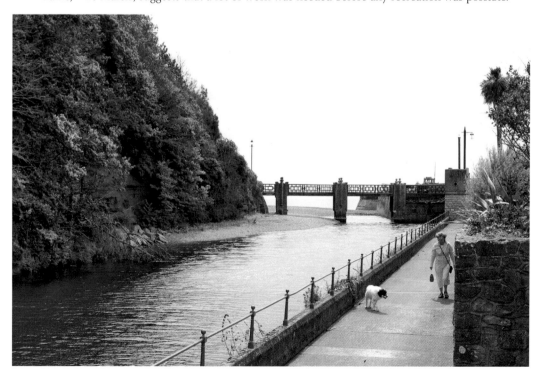

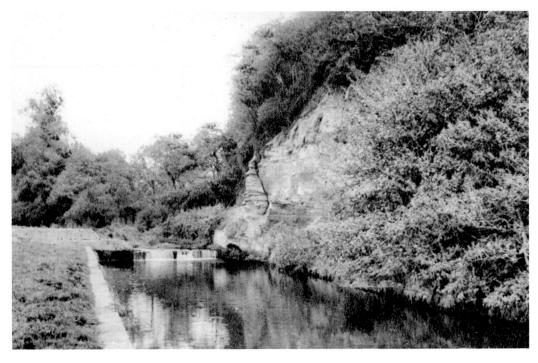

Weir, c. 1925
Turning around from the viewpoint in the previous old photograph, you get this view up to a little weir. However, this photograph is a little earlier, and you can see that the walkway beside the river has not yet been constructed.

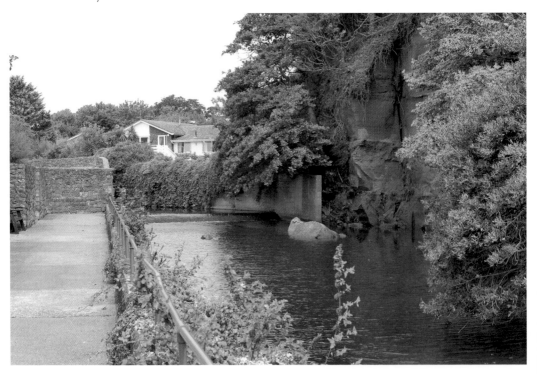

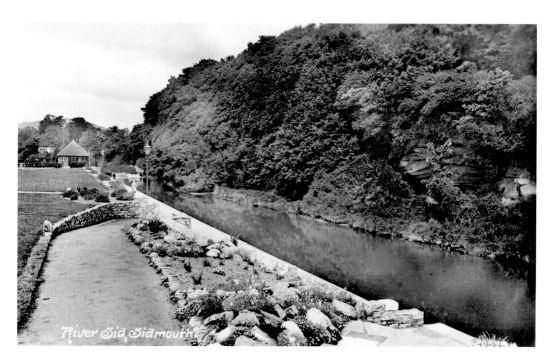

A 'Lost View', c. 1930

The old photograph here is a wider view of the previous one, taken from the top of the path down to the walkway from the Recreational Field. As my photograph illustrates, the raising of the walls beside the path and the growth of the vegetation that looks newly-planted in the old photograph, means this view can no longer be had.

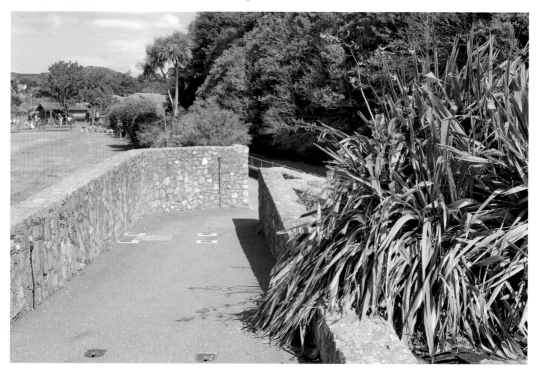

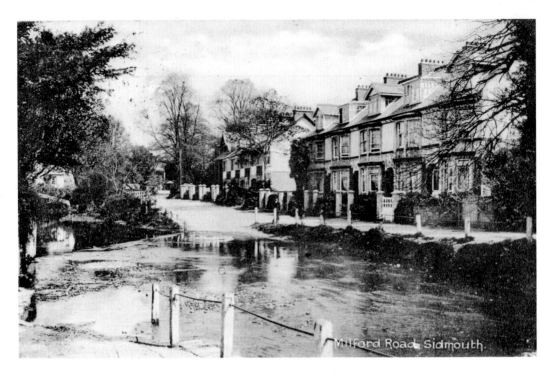

Ford by Milford Road, c. 1910

Next we head upstream and through the town to find this charming scene. As my photograph shows, the ford is still in use, although a lockable gate has been added for safety reasons. Part of the footbridge can be seen on the right in my shot.

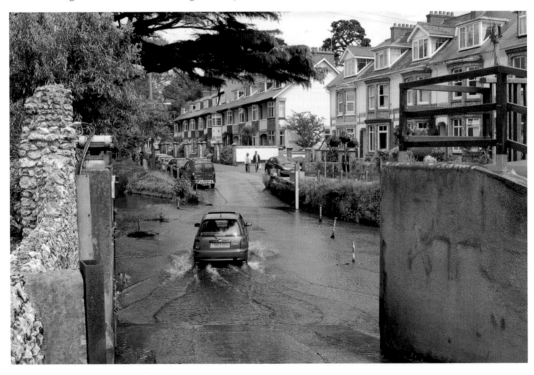

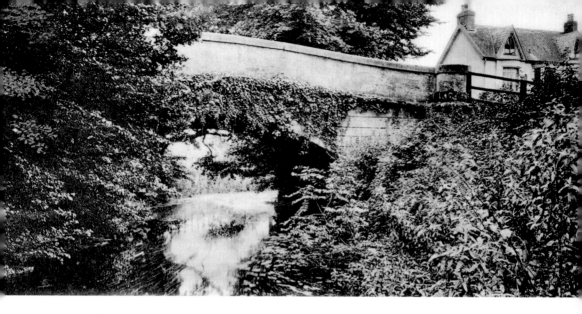

Salcombe Bridge, c. 1910

This attractive stone bridge is a little further upstream. It was constructed in the early nineteenth century to carry the road to Salcombe Regis over the Sid. The old photograph was taken from the upstream side, but the viewpoint is now inaccessible, so mine looks from the downstream side in Milford Road.

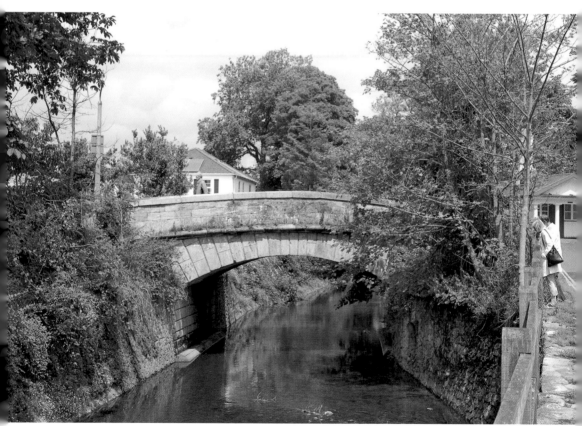

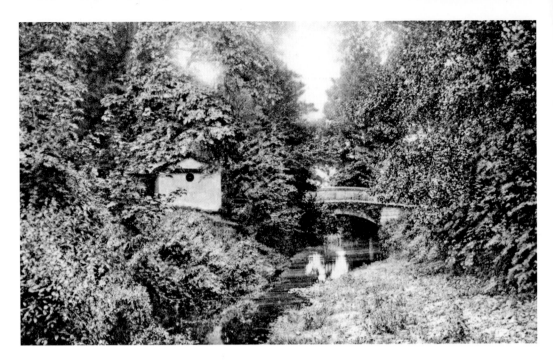

Salcombe Bridge, c. 1910

I think this old photograph again shows Salcombe Bridge together with the back of the toll house on its east side, and was taken from further upstream than the previous one. Today this view is obscured by vegetation, so my photograph shows the waterfall near the spot where the old photograph was probably taken.

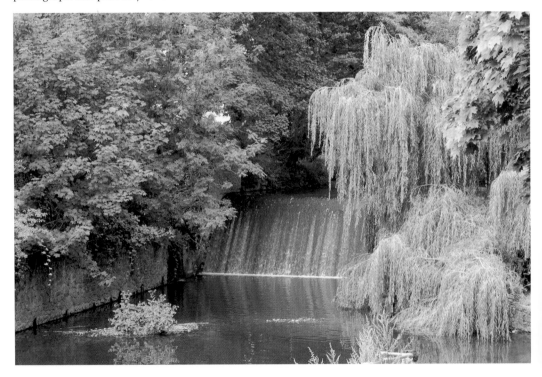

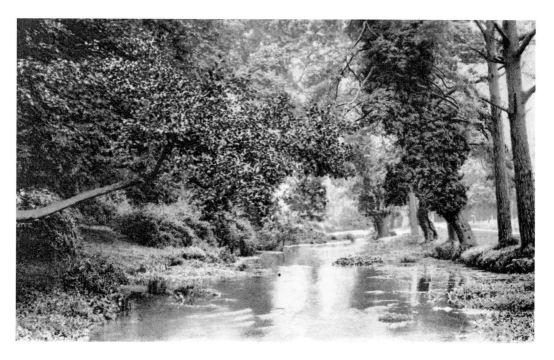

Sid Meadow

The Byes is the walk along the River Sid that starts in the park near Salcombe Bridge and heads up to Sidbury. It was laid out by the Sid Vale Association between 1850 and 1908. The old photograph was taken in what is now Sid Meadow; close to where there is now a bridge for a cycle path (and from where I took my photograph).

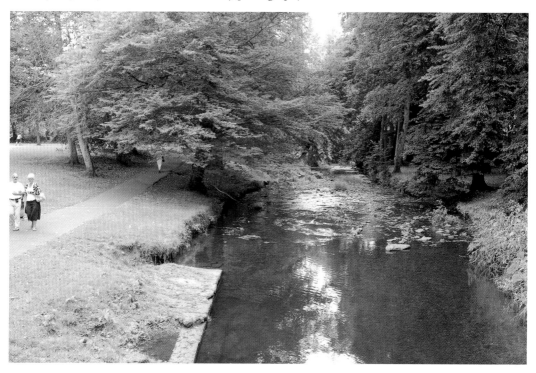

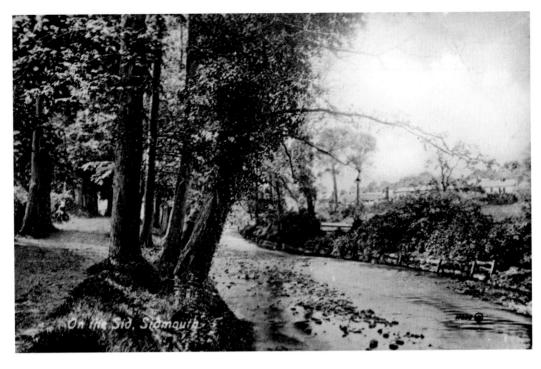

River Sid, *c.* 1910
Despite some searching, I could not identify the spot where this picture was taken with certainty. My best guess is that it was a little further upstream from the previous location, but do please hunt out this spot and see if you agree with me.

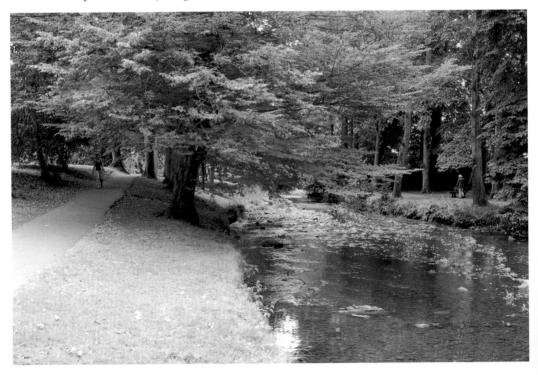

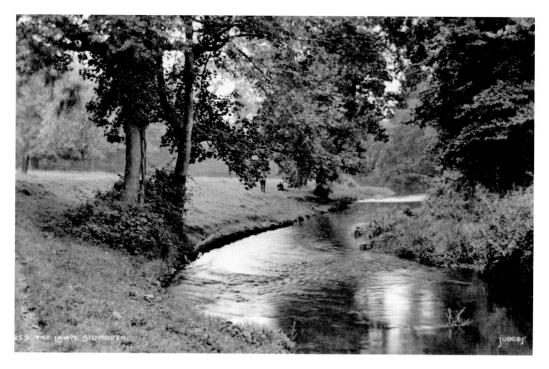

River Sid, *c.* 1930
Another bit of guesswork here. I think this photograph was probably taken a few hundred yards further upstream at a bend just below Margaret's Meadow, but again please have a look and see what you think.

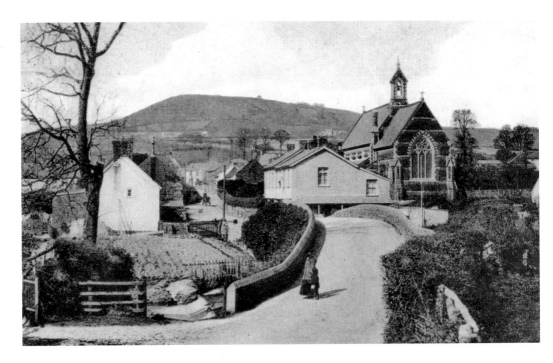

Sidford, Bridge, c. 1905

About a mile further upstream, we come to Sidford. This was formerly a separate village, but Sidmouth has now stretched out to link up with it. The place name suggests there was originally a ford here, but the bridge in these pictures has been here since at least 1633, and perhaps several centuries more. In 1930, the bridge was widened, and apparently the two parapet walls of the original were used to define the footpath that can be seen on the right side of the bridge in my photograph.

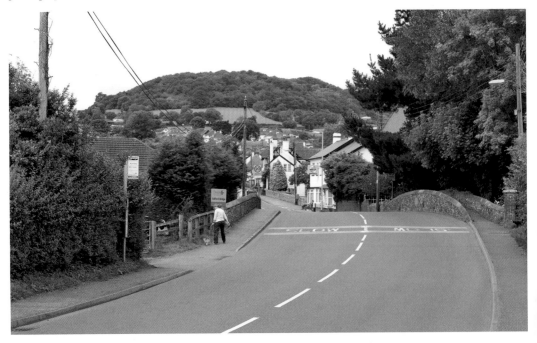

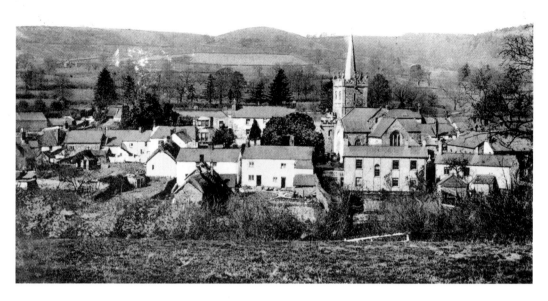

Sidbury, View of the Village, c. 1900

Sidford is the limit of the urban area and another mile or so further up the Sid valley we come to the separate village of Sidbury. The place had its own market and fair from 1290, and before the growth of Sidmouth it would have been the principal settlement in the valley. This pair of pictures were taken from the rising ground on the east side of the village.

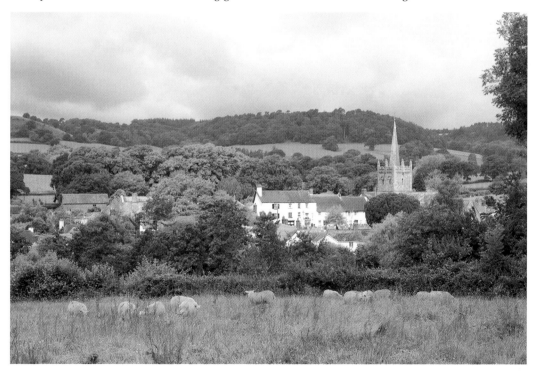

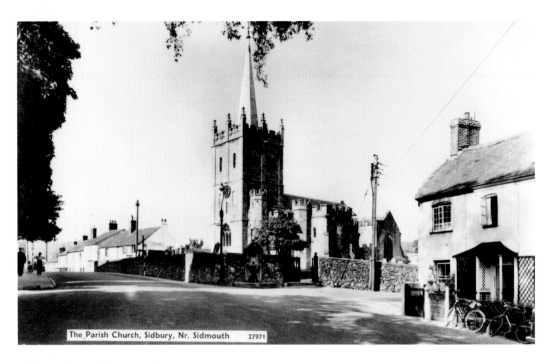

The Parish Church, Sidbury, Nr. Sidmouth 27971

Sidbury, Central Crossroads, *c.* 1935

We go down into the middle of this pretty little village now. The parish church contains stonework from a number of different periods, and beneath it there is a Saxon crypt, which is sometimes opened for tours. A fountain can be seen on the front corner of churchyard – it was built to commemorate Queen Victoria's Golden Jubilee of 1887.

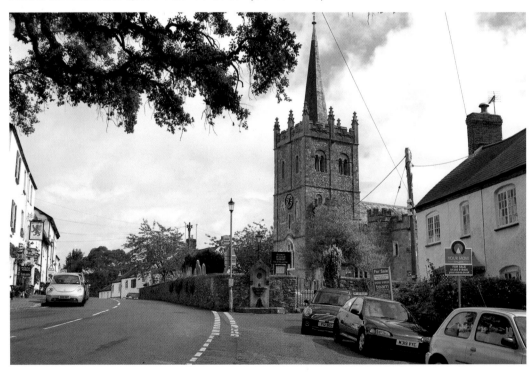

Salcombe Regis

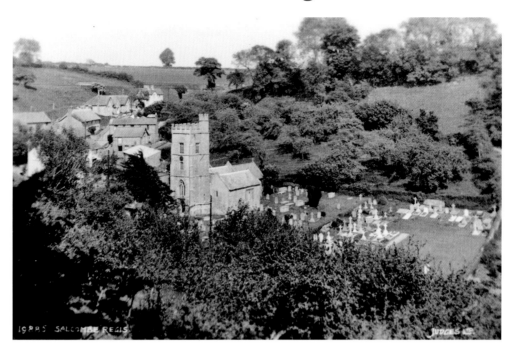

View of the Village, c. 1925
A couple of miles east of Sidmouth across Salcombe Hill we find the village of Salcombe Regis. It has a superb setting at the head of a narrow, short valley that leads quite steeply down to the sea.

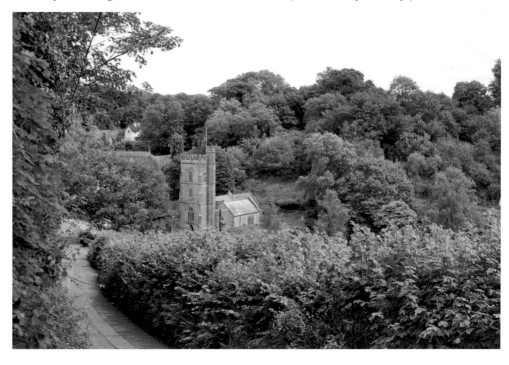

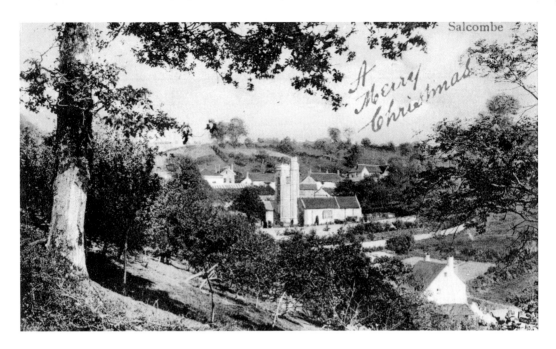

Parish Church, c. 1905

The viewpoint of this old photograph is not accessible, so my photograph is a close-up of the church. The building makes an excellent centrepiece for the village and is well worth a visit. Look out for the little carving of a pig's snout on the outside north wall of the chancel, which was presumably intended as an insult during some long-forgotten squabble.

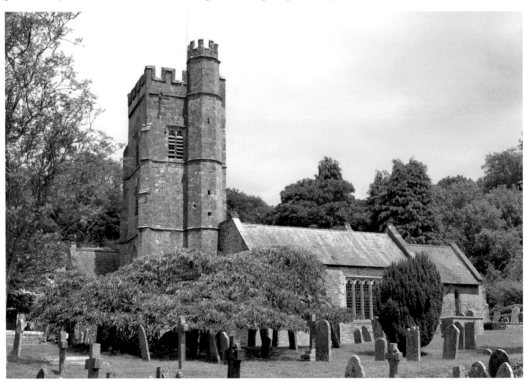

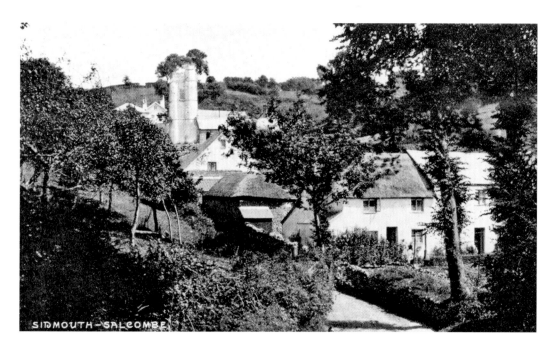

SIDMOUTH-SALCOMBE

Down the Lane, *c.* 1920

Here is a view back up towards the church from the lane down to the sea. It looks as though the two cottages on the right in the old picture have now been amalgamated. The place was a Royal Manor in the time of Alfred the Great, which explains the 'Regis' part of the name, and rather helpfully distinguishes it from the other Devon Salcombe, which is down on the South Coast.

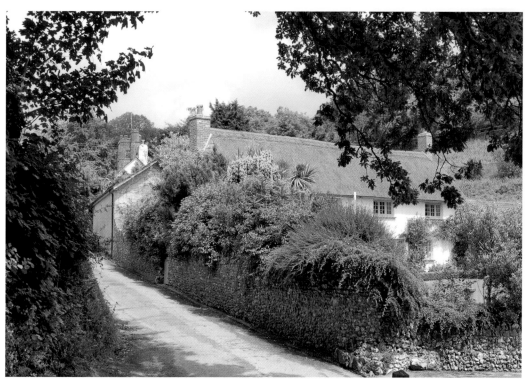

Branscombe

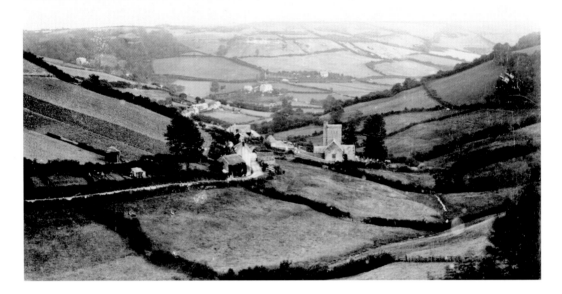

View Down the Valley, *c.* 1920
Now we head three or four more miles east along the coast to another place in a valley. In the case of Branscombe, though, the valley is much larger and the settlement is more dispersed – in fact, it would be better described as a chain of villages and hamlets. The pictures here are arranged in the form of a tour through the lower part of this chain, and we begin at Ball Hill looking down towards the parish church.

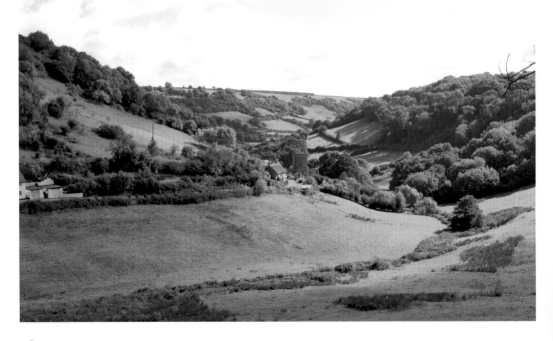

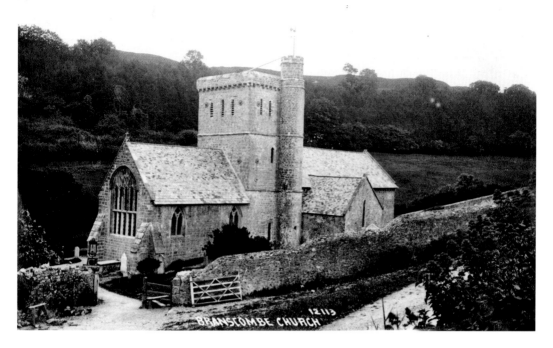

Parish Church, *c.* 1910

Like the one at Salcombe Regis, Branscombe's parish church is sited in a prominent spot in the upper part of the valley. It is full of features that make for a fascinating visit, including the Elizabethan gallery with a rare outside staircase and one of only two three-deck pulpits in Devon, not to mention the fifteenth-century wall-painting of a devil spearing a couple that it has caught 'embracing'.

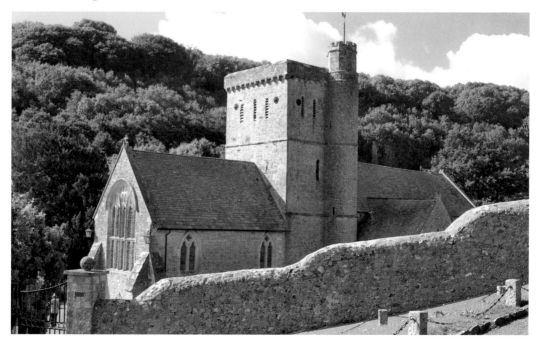

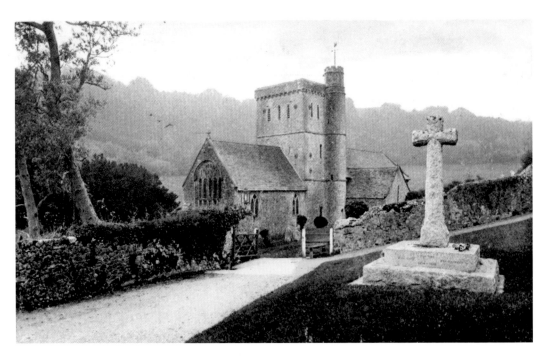

War Memorial, *c.* 1935
A similar view to the previous, but the old photograph here shows the war memorial erected by the entrance to the churchyard after the First World War. It is inscribed with the words 'For God, For King, For Country' as well as the names of twelve local men who were killed in that conflict. The names of three more men killed in the Second World War have since been added.

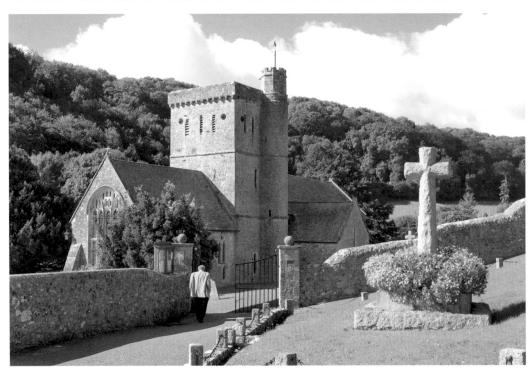

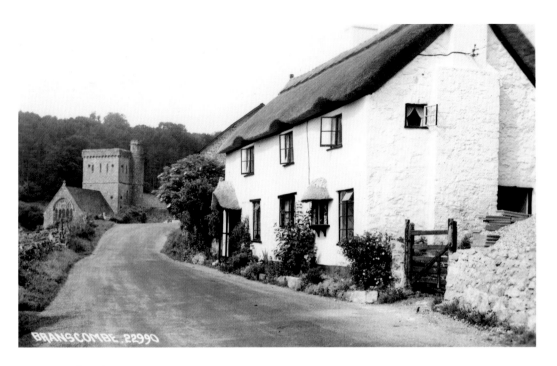

Rosechurch Cottage, *c.* 1930

Heading a short distance along the road that runs down the valley and looking back towards the church, we are rewarded with this view. We sometimes think that pretty thatched cottages like the eighteenth-century example here are unchanging, but there are quite a few differences between the two photographs. The removal of the render to expose the stonework and the addition of a small extension are just two of the changes.

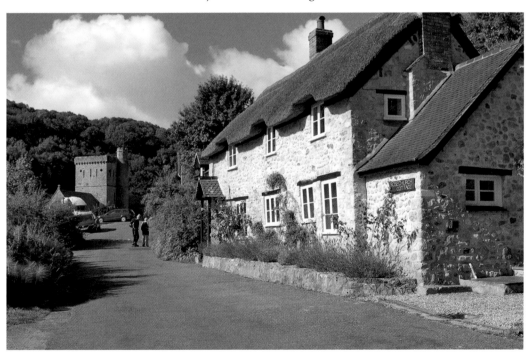

Thatched Cottages, *c.* 1930

Travelling onward, we find this view as we drop down into the next hamlet. The pair of 300-year-old cottages on the right may originally have been four properties. Some alterations have taken place between the two photographs being taken – for instance, what looks like a door in the end wall facing us has been replaced by a window.

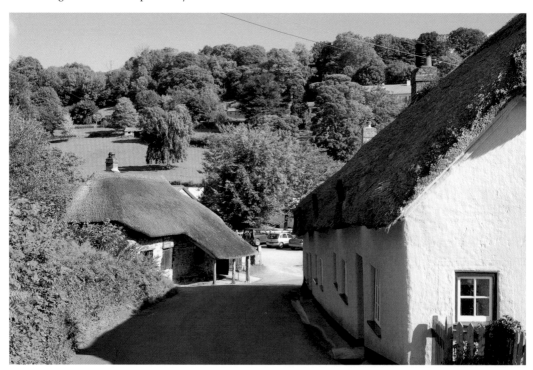

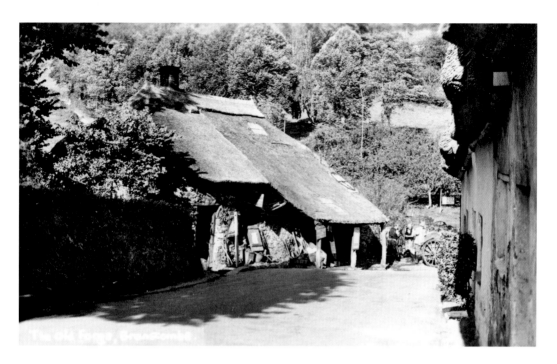

The Forge, *c.* 1930
Now we move in for a closer view of the building in the background of the previous pair of views. Branscombe Forge is one of three properties in Branscombe that belong to the National Trust (the others being the Old Bakery across the road and Manor Mill a little further away down a lane). It is a working forge and some of the products are on display inside.

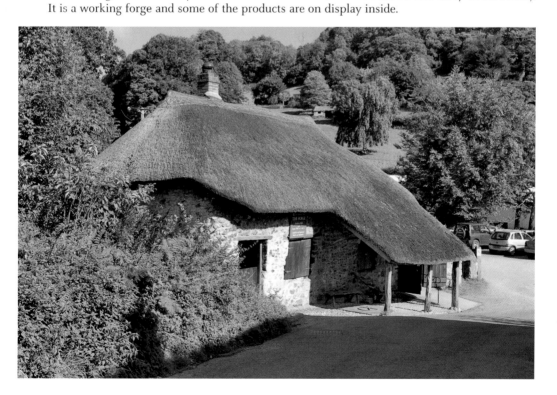

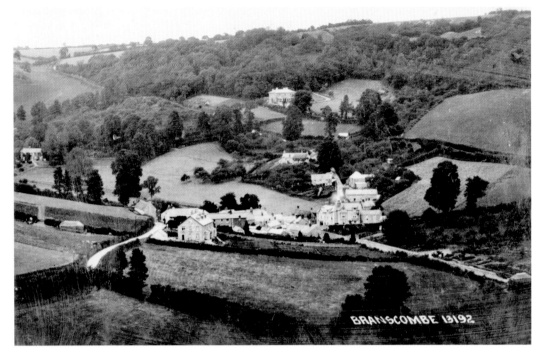

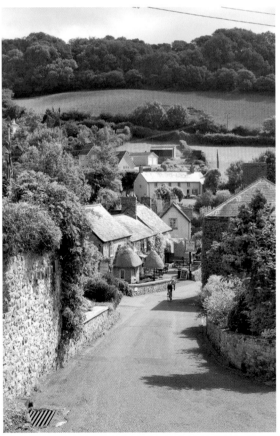

Vicarage, c. 1920

Next we head a few hundred yards further down the valley to the largest of the settlements, which is sometimes seen as 'the' Branscombe or the main village but which is called 'Vicarage' on maps. The old picture was taken from private land up on Margell's Hill to the west, and mine was shot from lower in Vicarage itself, with the Masons Arms Hotel in the middle of the picture.

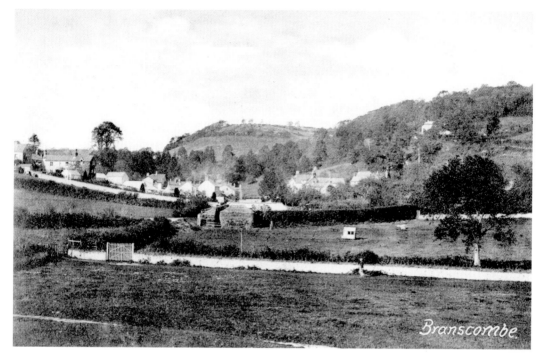

Vicarage, *c.* 1910

Here we have swung round to the south for a view of the same settlement from the valley bottom. The old photograph was taken from private land beyond the Old Mill Stream, and mine from the footpath closer in. The origin of the name 'Branscombe' is either 'black valley' or 'Bran's valley'.

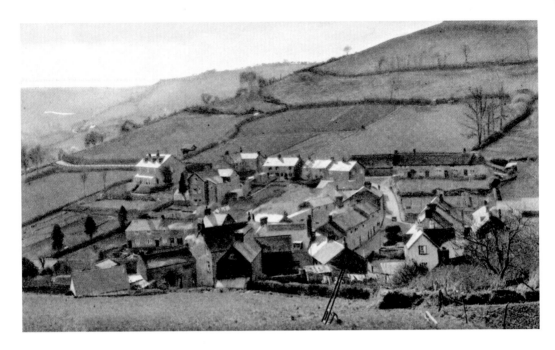

Vicarage, c. 1925

Round through another ninety degrees and looking down from the lane that bypasses the settlement along the hillside we get this view. You might be able to make out the sign of the Masons Arms by the road on the right.

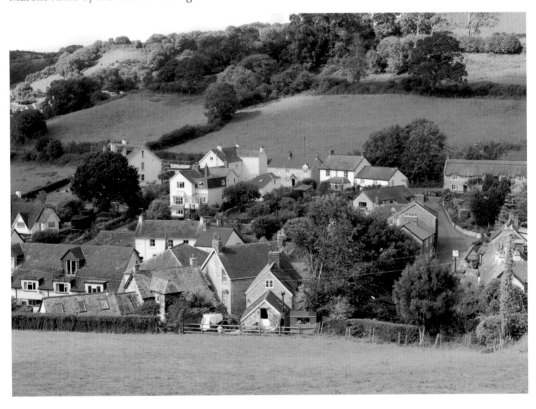

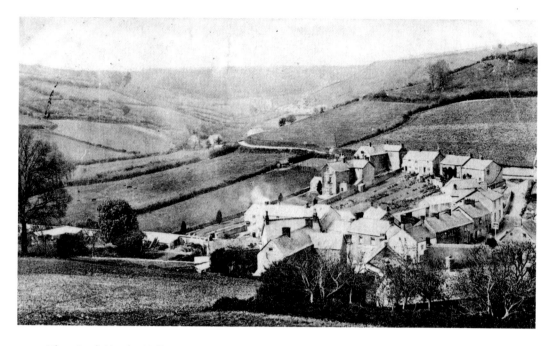

View Back Up the Valley, c. 1900

Turning around to the left a little from close to the previous viewpoint we see this. A comparison of the two views shows that there has been some development in the valley over the past century, but not a great deal. The distance up the valley to the church shows just how spread out Branscombe is.

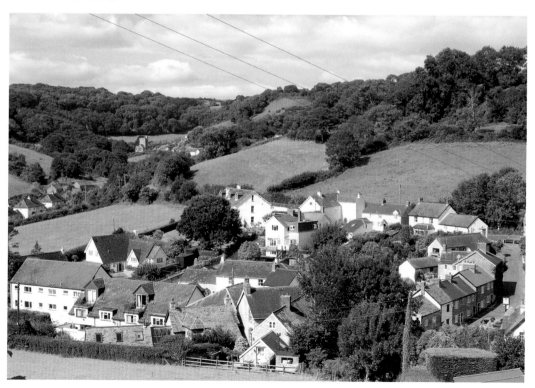

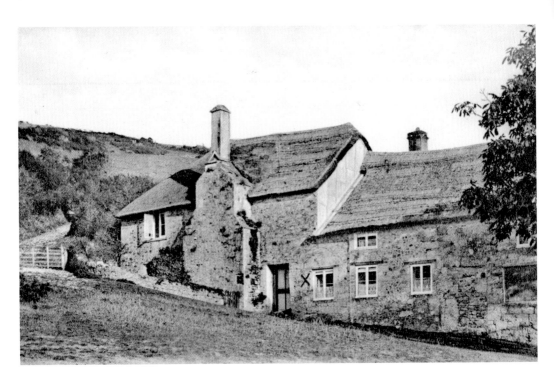

Great Seaside Farm, _c._ 1910

The road from Vicarage to the sea is about half a mile long. Just before it makes its final drop to Branscombe Mouth, we find Great Seaside Farm on the left. The farmhouse dates from the sixteenth century and is now a bed-and-breakfast establishment.

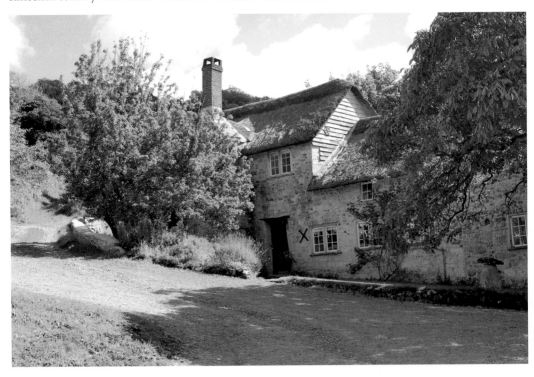

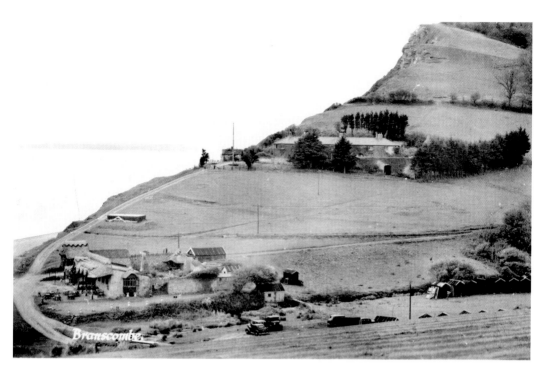

Branscombe Mouth, c. 1935

At last we reach the coast. The group of buildings at bottom left is the Sea Shanty. In the 1920s, a former coal yard, which had stored coal that was brought in by boat for the local lime industry, was converted into a café. It soon became a focus for visitors to the area and campsites grew up nearby. The premises now has the fuller title of the Sea Shanty Licensed Restaurant and Shop.

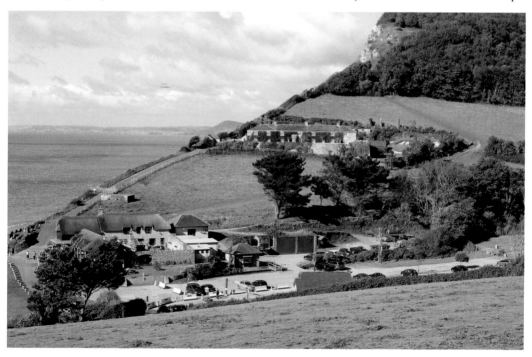

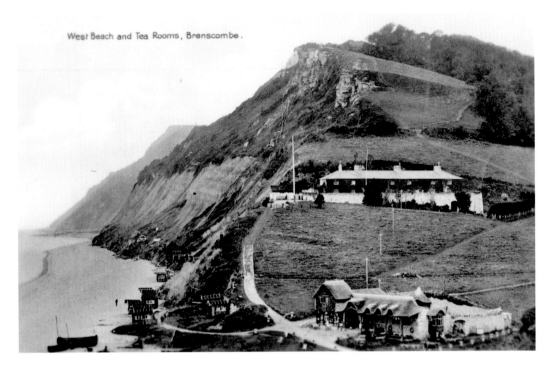

West Beach and Tea Rooms, Branscombe.

Branscombe Mouth, *c.* 1930
To get this view the photographer was probably standing on the cliff edge. The row of cottages higher up the cliff is the Look Out, built as coastguard cottages in the early nineteenth century – a time when those of that name literally guarded against smugglers rather more than watching for those in distress.

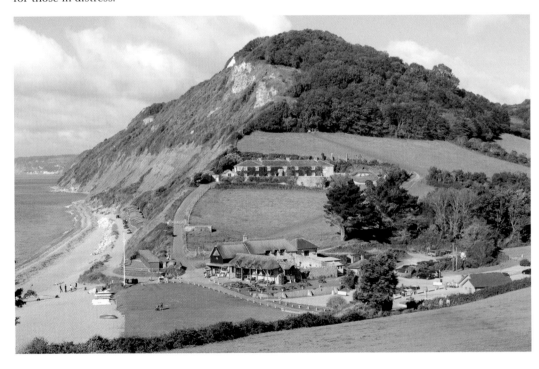

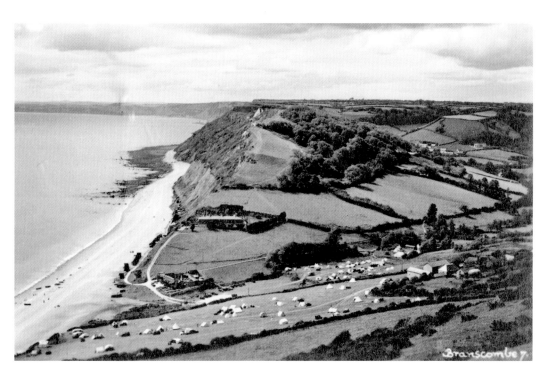

View from Branscombe East Cliff, *c*. 1935
Our final picture of Branscombe involves climbing higher up the East Cliff to gain a panoramic view. In the old photograph there are campers aplenty below, and we see more of West Cliff, where there is an Iron Age hillfort, and onwards to Sidmouth.

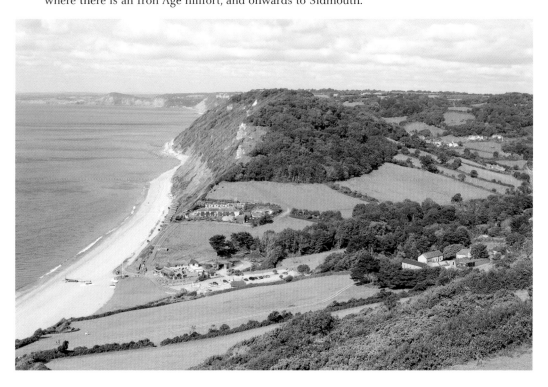

Beer

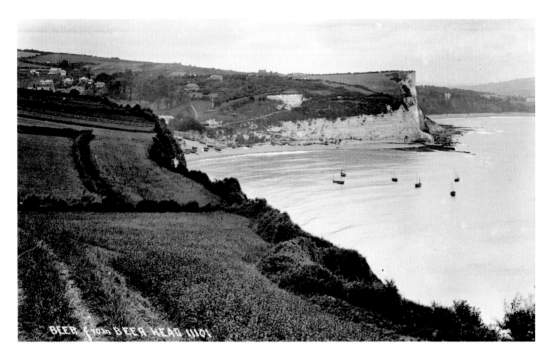

View from the South, *c.* 1920

Just a couple of miles east of Branscombe as the crow flies, or for the walker on the South West Coast Path, although further for those who drive around, we find the very different settlement of Beer. Here we see the east-facing cove, and in the older picture some of the fishing vessels that took advantage of the shelter it provided.

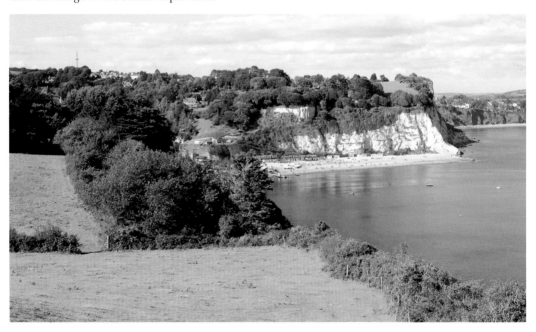

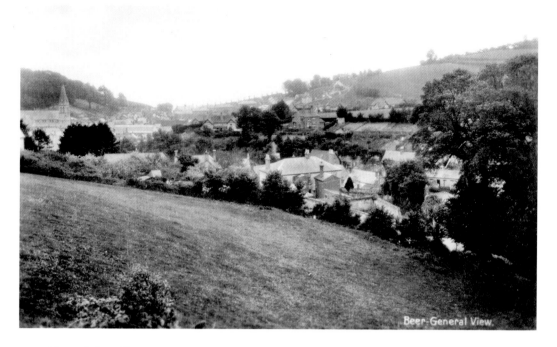

View of the Village, *c.* 1925

This old photograph is something of a lost view. My shot was taken from New Road, which heads out towards Seaton, but the other was taken from a spot to the south from where development now obscures the view. The origin of the name 'Beer' is not connected with alcoholic beverages, it comes rather from an Old English name for a grove of trees.

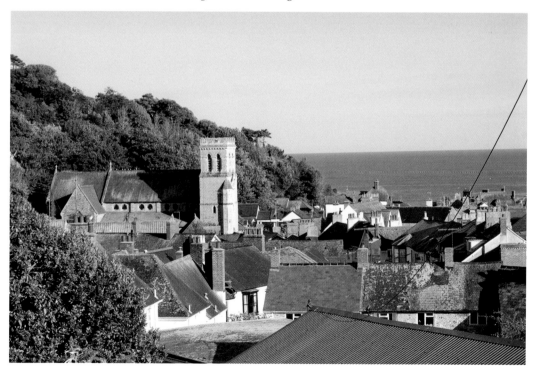

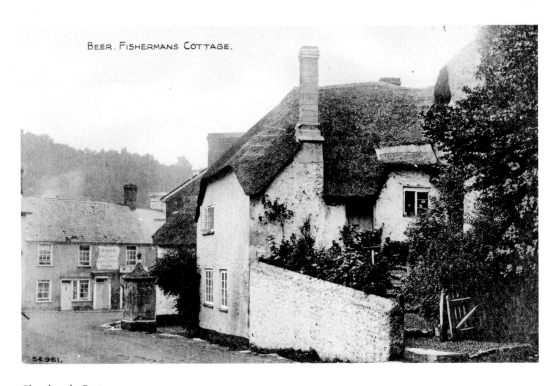

BEER. FISHERMANS COTTAGE.

Shepherds Cottage, *c.* 1910

As at Branscombe, we can use the old pictures to tour the village. We will begin at Shepherds Cottage, which is on the corner of Causeway and the Square, and will head from here down towards the beach.

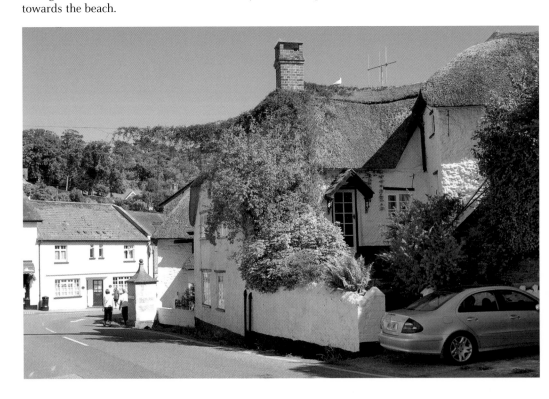

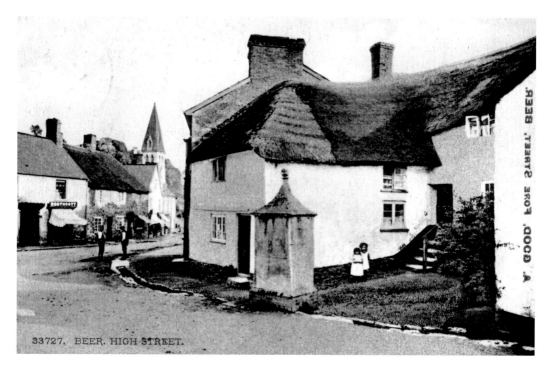

33727. BEER. HIGH STREET.

Shepherds Cottage, c. 1920

Here is the same property, now seen from a slightly different vantage point, which allows us to peer round into Fore Street. Shepherds Cottage was built, originally as several different properties, around three hundred years ago.

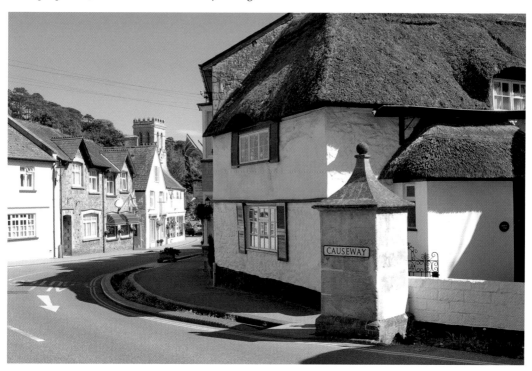

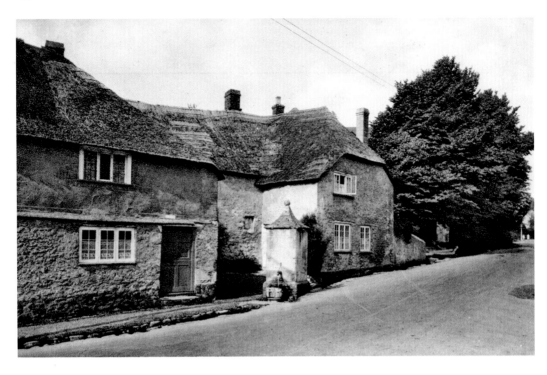

Shepherds Cottage, c. 1930

Next we move round into the Square and look back at the cottage. The stone structure in front of the property is one of two pumps that were constructed around 1700 over the stream that runs down through the village.

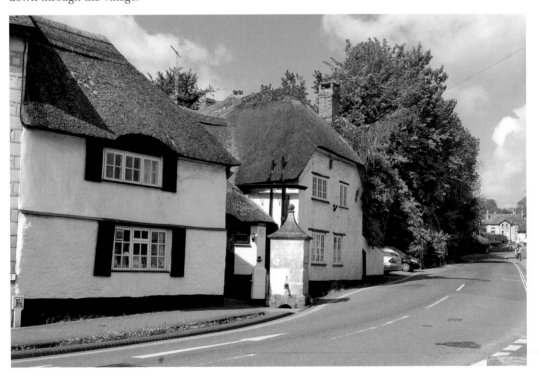

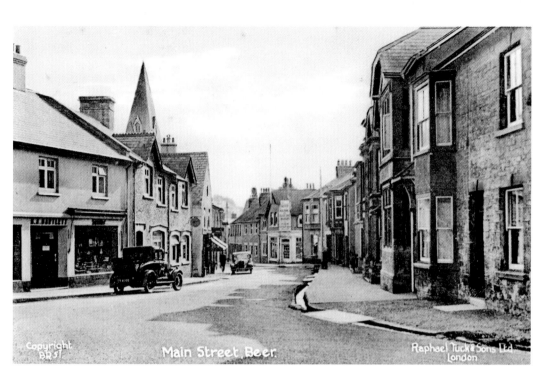

Fore Street, c. 1930
Turning around to look down Fore Street and crossing the road, we get this view. Comparing the older and present-day photographs shows a similar mix of shops, houses and guest houses, even though the individual functions of some properties have changed.

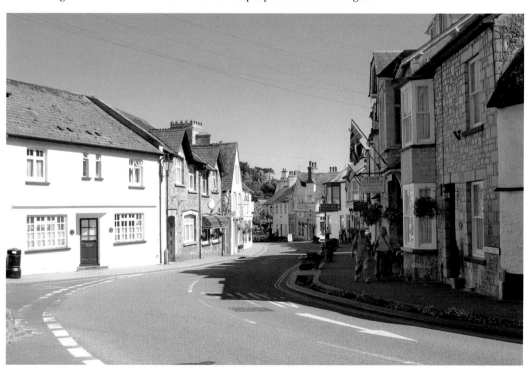

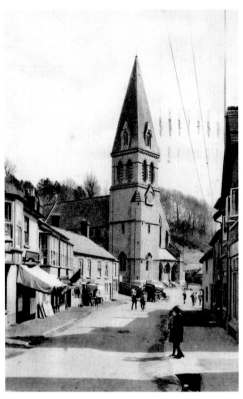

Parish Church, c. 1930
As you may well have noticed by now, Beer's
Victorian parish church has undergone
a rather drastic change – its spire has
been removed! According to the church
guidebook, this took place in the 1960s, as
it was presumably in a condition that was
considered unsafe.

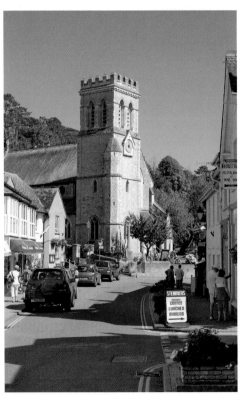

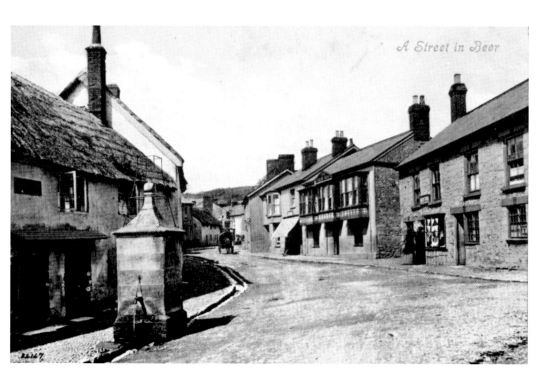

Looking Back Up Fore Street, *c.* 1910
These views were taken just outside the parish church, looking up towards the Square. The other pump is on the right, and on its nearest side you can see the pumping mechanism that brought water up from the stream underneath.

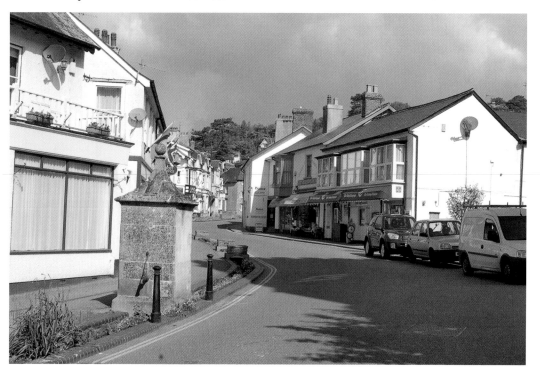

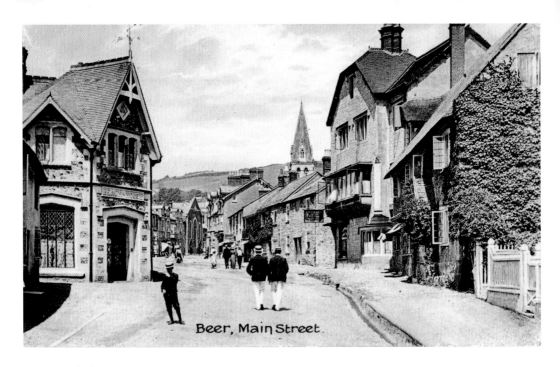

Beer, Main Street.

Lower End of Fore Street *c.* 1905

Almost down to the beach now, looking back inland we get this view. Much of what we see here was newly built when the old photograph was taken. Beach House (now renamed Beach Court) on the left had only been constructed in 1903, although the cottage on the right dates back to the early eighteenth century.

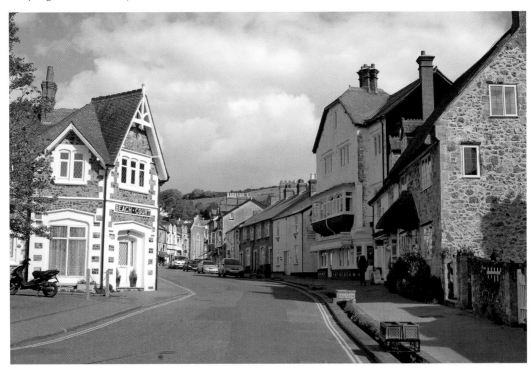

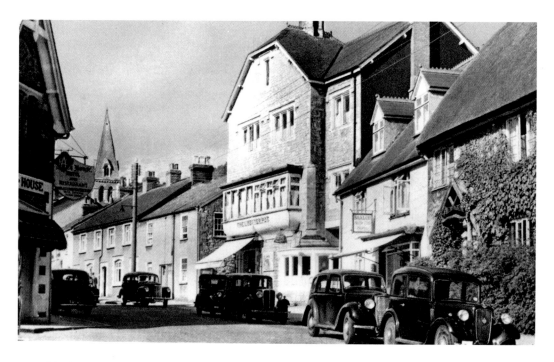

Marine House, *c.* 1935

Taken from a spot only a few steps away from the last old photograph, this picture is some thirty years younger. It focuses on the imposing three-storey Marine House, built perhaps a few years before Beach House in the Arts and Crafts style that went back to traditional workmanship and was influenced by older forms of architecture.

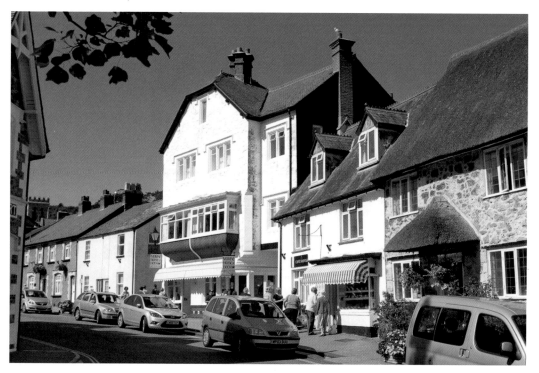

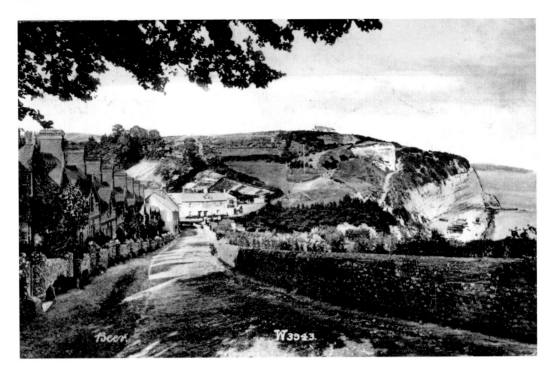

Sea View Terrace, *c.* 1900
Although now close to the sea, we divert south up Common Lane for a look at Sea View Terrace, a row of originally identical cottages built in 1873 by the local Rolle estate. It is also worth comparing the backgrounds of the two photographs – in the old the hillside on the other side of the village was open countryside.

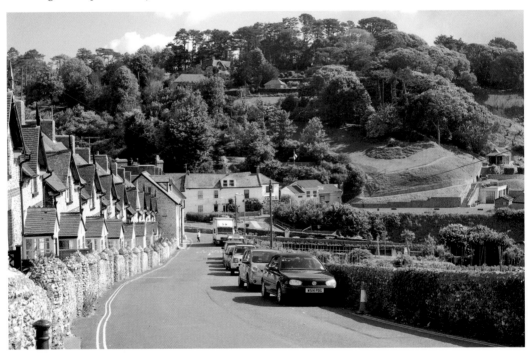

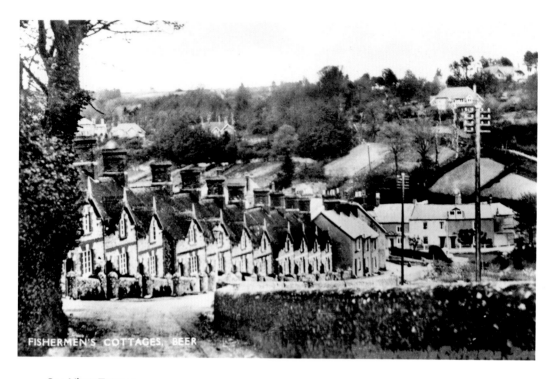

FISHERMEN'S COTTAGES, BEER

Sea View Terrace, *c.* 1930

A second view of the terrace taken from a little further up the lane. From this angle, you can see on the new photograph that most of the properties have had porches of the same design added.

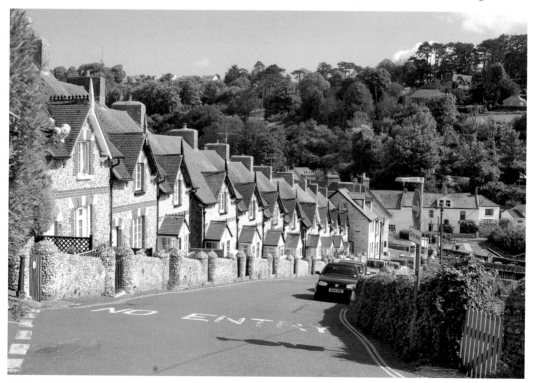

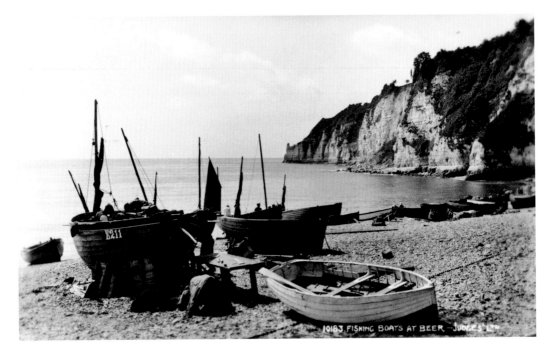

10183 FISHING BOATS AT BEER - JUDGES L.

The Beach, c. 1935

At last we reach the beach. As these pictures show, it is a shelving pebble beach well-suited to the storage of boats. Look at the next few old photographs and you will see that these vessels were once all fishing boats. They are still there, but they have been joined by leisure craft and the accoutrements of the tourism.

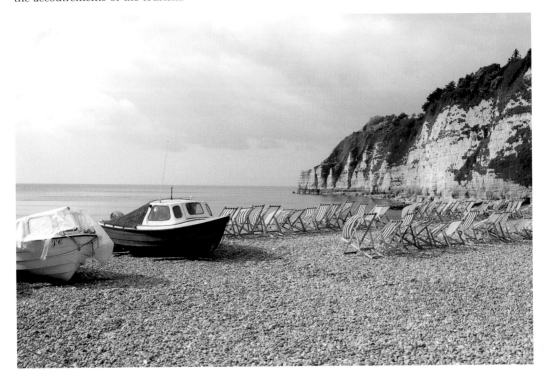

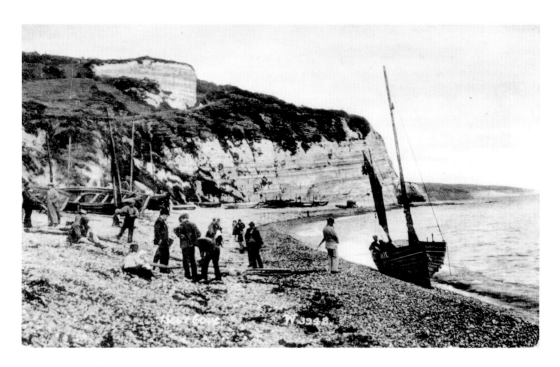

The Beach, c. 1900

Only a slight shift of position and a turn through forty-five degrees gives this view, looking along the beach to the east towards White Cliff. The old picture is a good three decades older than the last one, and seems to show lots of earnest thought and discussion of the business of fishing. The ropes on the ground in my photograph are attached to winches that bring fishing boats up onto the beach.

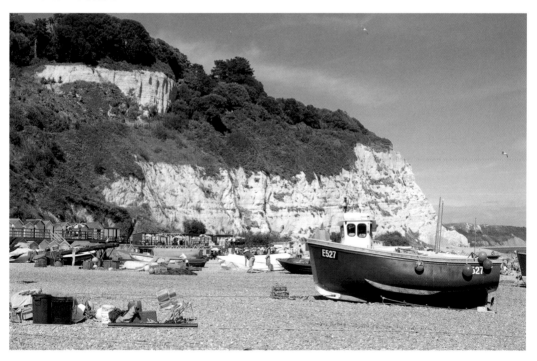

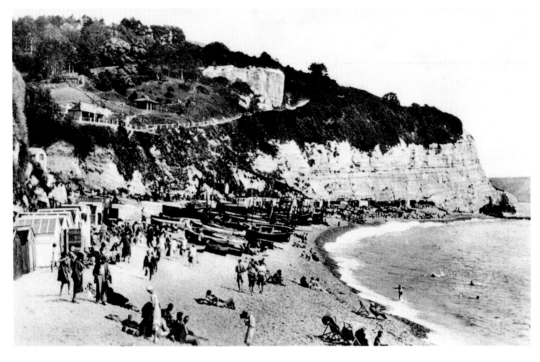

The Beach, *c.* 1935
Back again to the 1930s, and we see quite a change in the use of the beach. There are still plenty of fishing boats around, but now bathers and other holidaymakers have appeared in force.

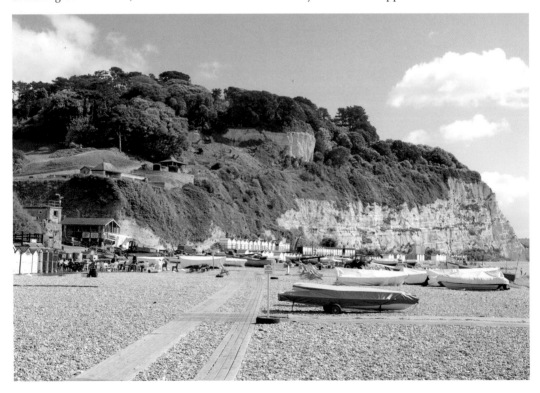

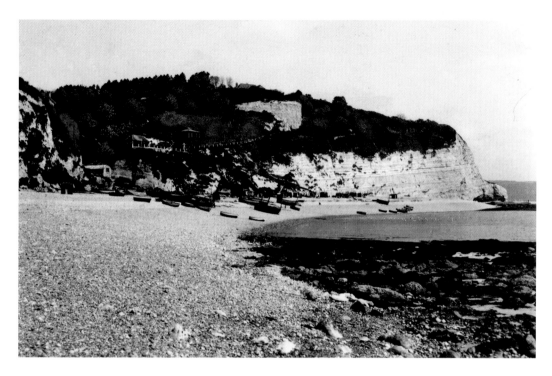

White Cliff, 1929

Here we step back not just in time but also to get a wider view of White Cliff. The outcrop of chalk that forms this and the other cliffs around Beer is the most westerly in England and makes this section of the coastline easily recognisable from many miles away around Lyme Bay.

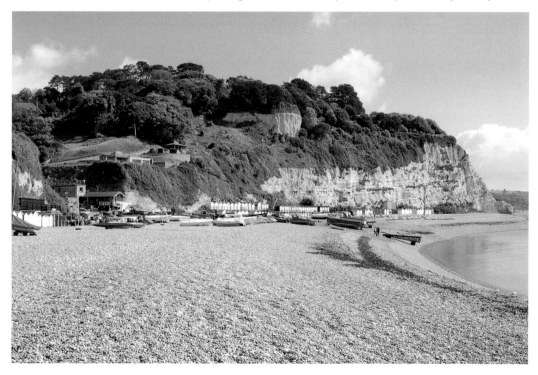

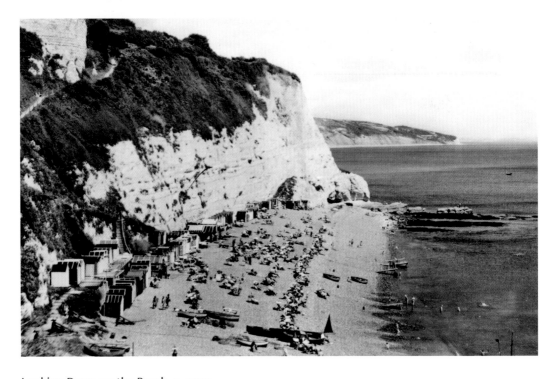

Looking Down on the Beach, *c.* 1935

The old photograph here must have been taken from the cliff edge by the allotment gardens opposite Sea View Gardens – I did not venture so close! We can see that beach huts had extended along the top of the beach by the 1930s.

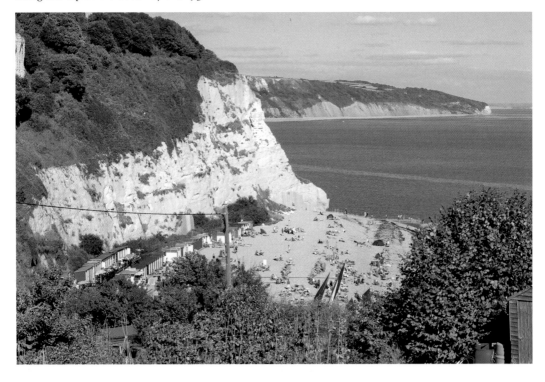

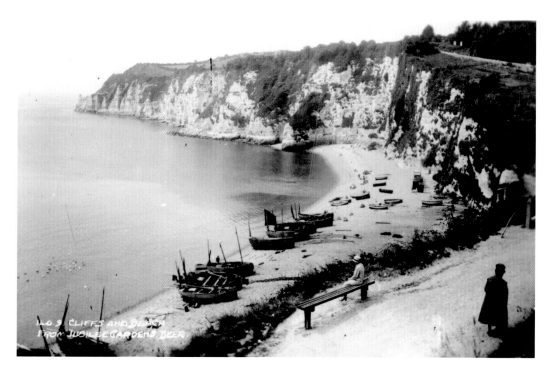

Across the Cove, *c.* 1930

Time now for a series of views from the other side of the cove, taken from on and around what is now the South West Coast Path as it heads up through Jubilee Memorial Grounds on its way towards Seaton and Dorset beyond.

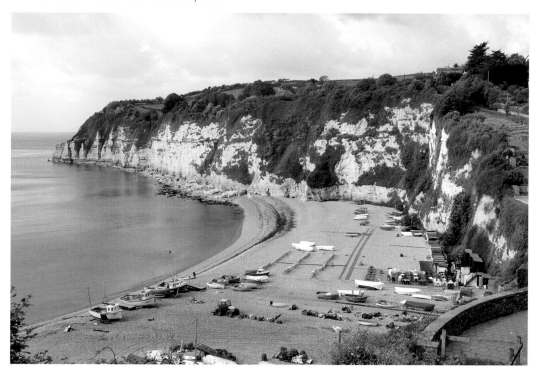

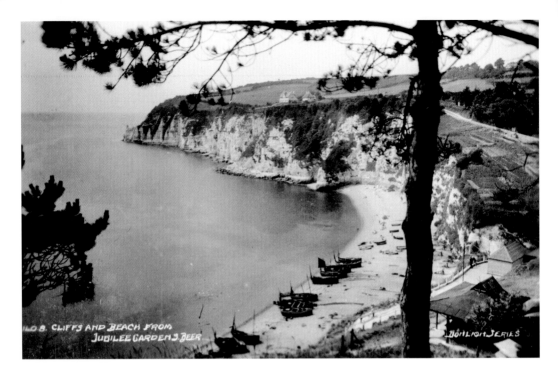

Higher Up the Path, *c.* 1930
Compare the wonderful collection of fishing boats and other paraphernalia in this old view with the previous one and you will see that the two photographs must have been taken at the same time. All that is different here is that the photographer is higher up, so that the shelter within the grounds has come into his camera's field of view.

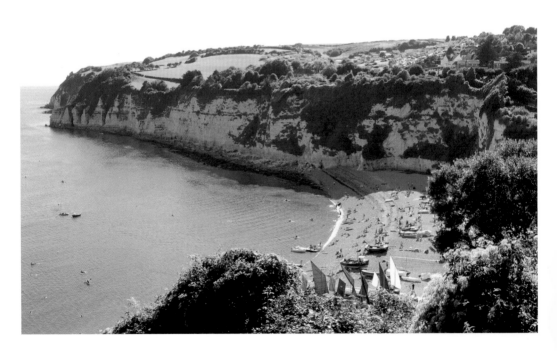

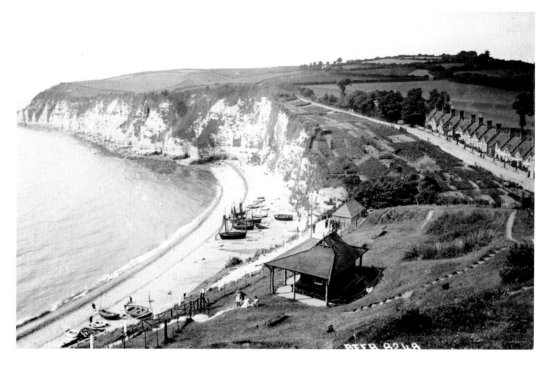

A Wider View, *c.* 1925

This photograph is taken from a spot quite close to the last one; however, it gives a better view of the shelter and of Sea View Terrace on the right. In this case and in the next, I was unable to take a photograph from exactly the same spot, but you can still compare to see how the land beyond Sea View Terrace has been developed.

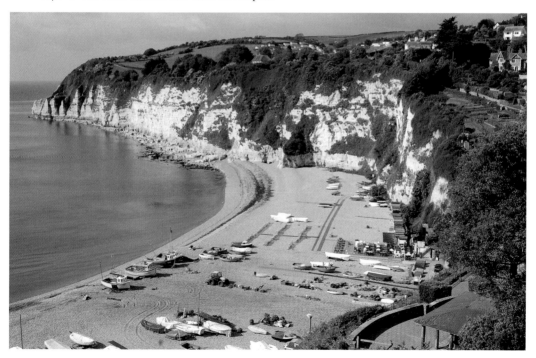

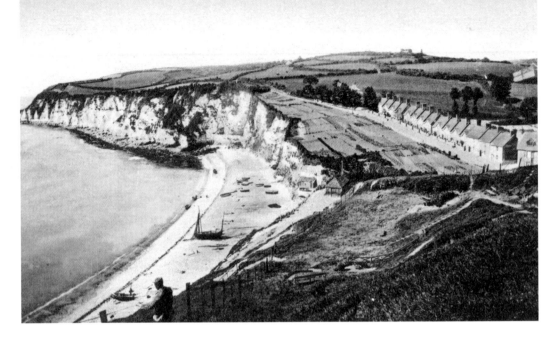

Near the Top, *c.* 1910

This is a rather earlier photograph taken from a little further up. It predates the building of the shelter, although it shows the steps beside the latter that can be seen in the last old photograph. The whole of Sea View Terrace and part of the Anchor Inn at the bottom of Common Lane can be seen now.

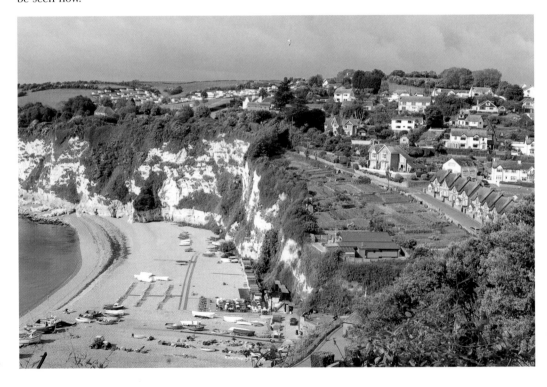

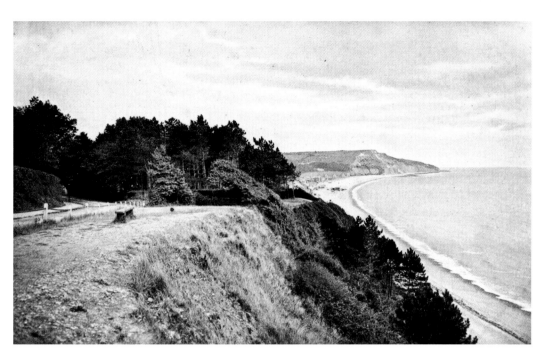

View from the Old Beer Road, *c.*1925

Next we go over White Cliff and partway down towards Seaton. Much of the road between Beer and Seaton has been moved inland since the old photograph was taken, and although an Old Beer Road still exists, I believe the section shown in the old photograph is now out of use if not lost altogether. My photograph was taking from closer to Seaton and shows more of its seafront.

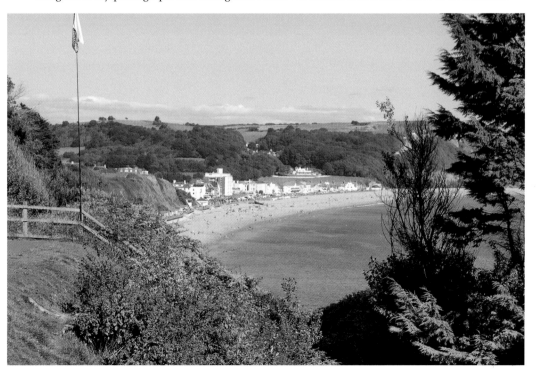

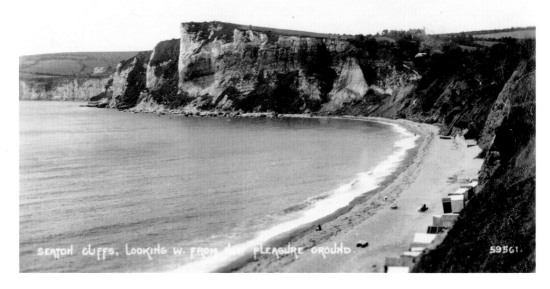

View Back Towards Beer, *c.* 1925

And finally, here is a reverse view of the previous pair, looking back at White Cliff from the Seaton side. The opening of the Beer cove is visible on the left, and the modern view also shows Beer Head Caravan Park on the opposite side of Beer.

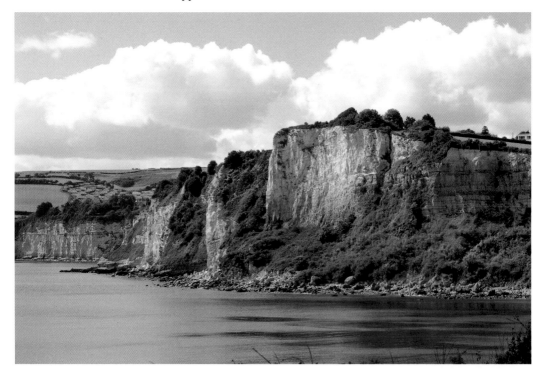

STEVE WALLIS

DORSET

THROUGH TIME

DORSET THROUGH TIME
Steve Wallis

This fascinating selection of photographs traces
some of the many ways in which Dorset has
changed and developed over the last century.

978 1 4456 0565 4
96 pages, full colour

Available from all good bookshops or order direct
from our website www.amberleybooks.com